WORLD FILM LOCATIONS MALTA

Edited by Jean Pierre Borg and Charlie Cauchi

T0345370

First Published in the UK in 2015 by Intellect Books, The Mill, Parnall Road, Fishponds, Bristol, BS16 3JG, UK

First Published in the USA in 2015 by Intellect Books, The University of Chicago Press, 1427 E. 60th Street, Chicago, IL 60637, USA

Copyright © 2015 Intellect Ltd

Cover photo: *Munich* (2005) DreamWorks SKG / Universal / The Kobal Collection / Ballard, Karen

Copy Editor: Emma Rhys

A Catalogue record for this book is available from the British Library

World Film Locations Series
ISSN: 2045-9009
eISSN: 2045-9017

World Film Locations Malta
ISBN: 978-1-78320-498-4
ePDF ISBN: 978-1-78320-499-1

Printed and bound by Bell & Bain Limited, Glasgow

WORLD FILM LOCATIONS
MALTA

EDITORS
Jean Pierre Borg and Charlie Cauchi

SERIES EDITOR & DESIGN
Gabriel Solomons

CONTRIBUTORS
Giovanni Bonello
Marcelline Block
Rebecca Cremona
Guillaume Dreyfuss
Monika Maslowska
Jake Mayle
Kenneth Scicluna
Marc Zimmermann

LOCATION PHOTOGRAPHY
Jean Pierre Borg
Mark Cassar
Jake Kindred
Robert Racaru
Stefan Starface

LOCATION MAPS
Greg Orrom Swan

PUBLISHED BY
Intellect
The Mill, Parnall Road,
Fishponds, Bristol, BS16 3JG, UK
T: +44 (0) 117 9589910
F: +44 (0) 117 9589911
E: *info@intellectbooks.com*

with the initiative of Filmed in Malta and
supported by the Malta Film Commission

Bookends: Bus terminus (Mark Cassar)
This page: St John Street, Valletta (Jake Kindred)
Overleaf: On the set of *Gladiator* (2000)

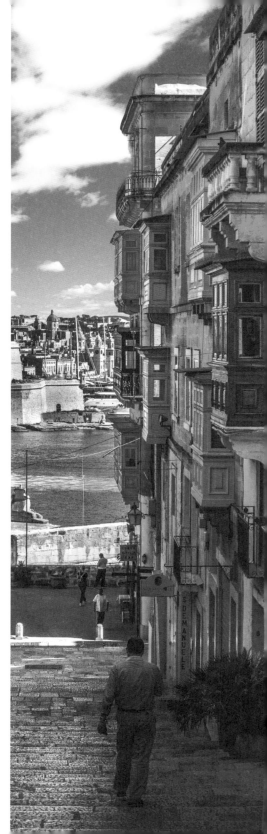

CONTENTS

ACKNOWLEDGEMENTS

We are grateful to those who have
contributed to this edition of the
World Film Locations series and
are indebted to all the film-makers
and production teams, local or
otherwise, that have chosen to make
their pictures on our shores. We
would like to extend our gratitude
to Gabriel Solomons at Intellect,
Guy Hendrix Dyas, Marlene and
Benjamin Borg, Joel Pullin, Mike
Anderson, Nolan & Palmer, Hannah
Maxwell and Joshua de Giorgio.

JEAN PIERRE BORG
AND CHARLIE CAUCHI

INTRODUCTION

World Film Locations Malta

IN A DISTINCT DEPARTURE FROM the other editions that make up the *World Film Locations* series, this book is concerned with an island rather than a city. Given Malta's diminutive size, both in terms of its population (approx. 420,000) and land mass (316 km²), we have re-shifted our focus to concentrate on Malta in its entirety, thereby also including the sister islands of Gozo, Comino and Cominotto. This book draws together essays from film scholars, film historians, film-makers, heritage conservationists and industry professionals, calling attention to significant films, cultural movements and key players in the process.

A little under a century ago, Malta's appearance on-screen was mainly influenced by its strategic position at the heart of the Mediterranean and its status as part of the British Empire. The islands therefore featured in a number of British films that focused on military operations, specifically those associated with World Wars I and II. After Malta gained its independence in 1964, productions originating from outside the United Kingdom also saw the benefits of using Malta as a filming location. While the types of genres became a little more varied, it was the water tank at Rinella that proved to be a draw. Here we must acknowledge the work of a number of key individuals, including Benjamin Hole, Lino Cassar, Paul Avellino, Narcy Calamatta and Ino Bonello, amongst others. However, it was Ridley Scott's *Gladiator,* which was filmed in Malta in 1999 and released in 2000, that is generally seen to have reinvigorated Malta's film servicing industry, boosting Malta's cinematic presence in the process.

From *Gladiator* onwards, Malta made a concerted effort to attract more foreign productions to its shores, including the establishment of a film commission and the introduction of financial incentives. Since then, Malta has matured into a 'film friendly' island, successfully attracting a wide range of foreign productions, not solely because of the surface sea-facing water tanks, or its ideal climate, but also thanks to its versatile natural and architectural landscape. Although local film-making has been slow to take off, much change has taken place in recent years, with the introduction of national incentives and structural changes to support Malta's own film-making output.

In a book of this size, one can only offer a taster, rather than an exhaustive analysis, of film-making within the nation, be it foreign or Maltese. But we hope that through the examination of a broad range of film titles, alongside the more focused Spotlight Essays, that this publication will whet the appetite of locals, travellers and film enthusiasts alike. ✢

Jean Pierre Borg and Charlie Cauchi, Editors

MALTA

Text by
CHARLIE
CAUCHI

Island of the Imagination

NETS, WOOD, PAINT, GRIT, GRAVEL – all have been applied to the sandy limestone surface of this island archipelago, and all in the name of cinema. Malta's rural and urban landscape has functioned as a veritable blank canvas, ready to be shaped by the film-makers that visit and to serve the requirements of their own particular narratives. Epic tales, adventure films, spy movies – the island has made many a generic transformation over the years. On occasion, Malta flickers on the big screen in all its natural glory and, albeit rarely, is even given the chance to play itself. But more often than not, the country acts as a surrogate for other places – either real or fantasy spaces, set in contemporary or distant times, often disguised to the point that it is rendered unrecognizable to those who know it well.

Writing as someone who has a strong connection with Malta, I find that my own cultural identity, age and life experiences can often conflict with the cinematic representation placed before me. At times running counter to my own lived-in knowledge, these on-screen manifestations lead to a desire to pinpoint each exact location and to unpick the geographic reality of each scene. When watching a film I know was shot on location in Malta, I occasionally find that I become more preoccupied with the off-screen spaces, with what lies beyond the image, rather than the image itself. What do these props, edits, camera angles conceal rather than reveal? Do not read my lack of engagement with the film as disinterest. Rather, the more difficult it is to verify a particular place can be seen as testament to the director's vision and, more importantly, the skills of the countless other individuals that make such transformations possible. And lest I forget, the versatile actor at the heart of it all: Malta.

My own emotional attachment aside, architect Conrad Thake describes Malta's landscape as being 'highly discontinuous in its physical structure, reflecting the diverse settlement patterns and urban forms that were introduced over various centuries by Arab and later European cultures' (p.38). A palimpsest of past conquests and cultures, it is Malta's hybridity, its position between the East and the West that makes it suitable to convey the reality that it purports to represent. Take Steven Spielberg's *Munich* (2005) as a prime example; a tour de force for production designer Rick Carter, costume designer Joanna Johnston and cinematographer Janusz Kaminski, who are all incidentally close collaborators of the renowned director. The film's central premise has Mossad agents travel to Athens, Beirut, Nicosia, Rome, Jerusalem, Tel Aviv and the West Bank to carry out their operation. In reality however, the production team barely used a fraction of the 316 km^2 that make up the Maltese islands.

In this case, certain aspects and features inherent to the chosen landscape were singled out and accentuated, while others were obscured or camouflaged. Either way, through the collaborative efforts and critical eye of the production team, each chosen space took on a personality of its own, demonstrating that objects, decor and colour can be an integral part of filming on location. To highlight a few examples, Valletta's baroque architecture is foregrounded to stand in for Rome; while Sliema, with its bustling seafront and intensely developed promenade of Bauhaus-esque apartment blocks, bears an uncanny resemblance to Tel Aviv – with some fine sand also thrown in (quite literally I expect) for good measure. Add a classic car here, some stay-press fabric there and, once you de-saturate the image, we have not only travelled to two completely different parts of the world, but both spaces have also transported the audience back in time to the 1970s.

Although *Munich* can be seen as a period drama, the island's rich history also attracts productions that are preoccupied with distant myths. The realist background that period films like *Munich* strive for are rejected in pictures like

Gladiator (Ridley Scott, 2000), *Troy* (Wolfgang Peterson, 2004) and *Agora* (Alejandro Amenábar, 2009) in favour of something more spectacular. In search of a landscape that can reinforce the historical image and add ideological precision to the overall narrative, many productions have exploited Malta's classical antiquity to restage the past. It was *Gladiator* that reignited the trend for epic tent-pole pictures, harking back to the Hollywood of the 1950s and 1960s, when titles like *The Ten Commandments* (Cecil B. DeMille, 1956), *Ben-Hur* (William Wyler, 1959) and *Spartacus* (Stanley Kubrick, 1960) dominated the box office. Unlike these latter-day films however, many of the modern epics are able to successfully combine the real and the digital to re-create a historical setting. However, it is the construction of elaborate sets that adds to the splendour and spectacle. The transformation is not incantatory. It takes the involvement of a lot of skilled individuals for a production to take shape, and Malta has a history of providing artisanal work of a high standard. One need only look to *Agora* and the large-scale set pieces that dominate the image as confirmation of the incredible craftsmanship that is available on the island. The film proved to be a great opportunity to showcase local talent.

Besides Malta's ability to flaunt its fluid identity, when disrobed, Malta's anatomy is often used to accentuate its exoticism. The island's rocky beaches and seascapes, bathed in a golden light, have been incorporated into many productions, though mostly as an anonymous background filler. 'I did not fly all the way from New York

City to wherever the f#$k we are…,' shrieks Amber (Madonna) in *Swept Away* (Guy Ritchie, 2002). In a sense, this loud-mouthed American has a point – the specificities of the location are skirted over in this film (in this particular scene, the 'wherever' is Vittoriosa Waterfront) and in many others, to exploit the standard myth of the idyllic Mediterranean setting. In contrast to the picturesque depictions, when Malta is named it is usually in the context of World War II or the British Empire. Given Malta's crucial position during World War II, it is understandable that film-makers would connect Malta to this turbulent time in history, either tackling it explicitly in films like *Malta Story* (Brian Desmond Hurst, 1953), or by embedding it in the narrative to add context.

Nevertheless, it is very rare that Malta's national history and contemporary social issues make their way on-screen. But this is slowly starting to change, with film-makers, screenwriters and artists who inhabit the island (either as nationals or citizens) starting to produce work that is told from an internal viewpoint. Local cinematic activity has already started to give rise to a number of productions that are not only rooted in this geographical context, but also embrace Malta's identity, traditions and characteristics. Examples to date include the work of Rebecca Cremona, Kenneth Scicluna, Mark Dingli, Martin Bonnici, Pierre Ellul, Bettina Hutschek, Jean Pierre Magro, Monika Maslowska, Joshua Cassar Gaspar, and many others whose imaginations have been sparked by this little island, allowing audiences to engage with it through cinema in new and exciting ways. ✢

maps are only to be taken as approximates

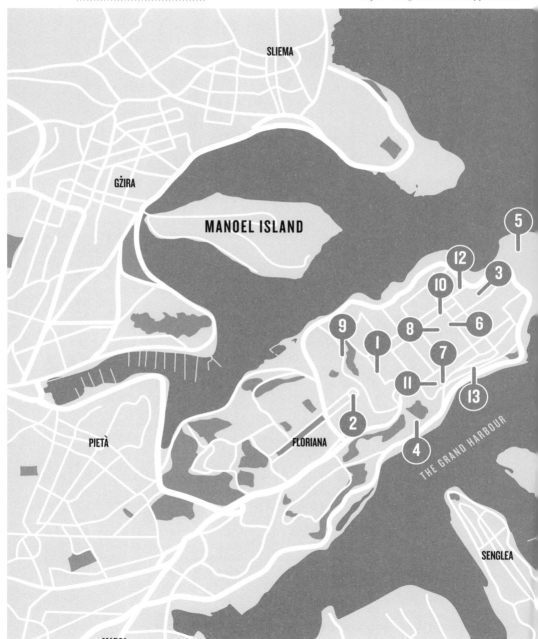

SLIEMA

GŻIRA

MANOEL ISLAND

PIETÀ

FLORIANA

SENGLEA

THE GRAND HARBOUR

MARSA

MALTA LOCATIONS
VALLETTA

MEDITERRANEAN SEA

KALKARA

ORIOSA

MALTA STORY (1953)

The Royal Opera House, Republic Str., Valletta

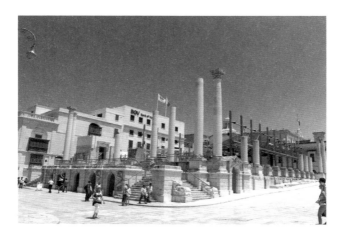

DURING HIS NIGHT-TIME DESCENT on Maltese land, RAF pilot Lt Peter Ross (Alec Guinness) turns to his flight companion Eden (Hugh Burden) and says, 'I would like to see Malta in daylight. I believe there's some very interesting Megalithic remains.' 'Well,' Eden wistfully replies, 'there are certainly some very interesting remains on Malta nowadays, Megalithic or otherwise.' Set against a backdrop of rubble and rations, director Brian Desmond Hurst evocatively illustrates the hardship suffered by the Maltese during World War II by interweaving authentic locations and archival footage. *Malta Story* was filmed and released just over a decade after the Siege of Malta, a battle that occurred between Allied and Axis forces from 1940 to 1942. The film's temporal setting is 1942, when Malta, still a British colony, suffered severe bombardment by Axis aircraft. The courage of the Maltese did not go unnoticed, that very year King George VI awarded Malta the George Cross for bravery. This sequence focuses on Ross and his inamorata Maria (Muriel Pavlow), who have joined the throng on the ruins of the once majestic Royal Opera House to listen to Governor Gort broadcast this news to the nation. The site was itself a casualty of war. Situated in Valletta, the Opera House was designed by British architect Edward Middleton Barry in the late 1800s. Initially it was a prestigious performance venue: this neoclassical structure catering mainly to Malta's elite. In fact, Guinness appeared there in 1939, when he played Hamlet in a production staged by the Old Vic Theatre. After its wartime destruction however, the Opera House remained derelict until it was redesigned by Renzo Piano and renovated in 2013. This image, heavy with the pains of the past, lies in stark contrast to the Valletta of now, a city reimagined, standing out on a global stage of arts and culture. **•→Charlie Cauchi**

Photo © Jean Pierre Borg

Directed by Brian Desmond Hurst
Scene description: Crowds gather as Governor Lord Gort speaks to the nation
Timecode for scene: 0:39:19 – 0:39:27

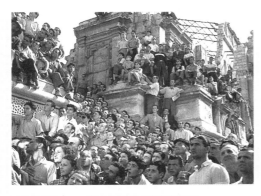
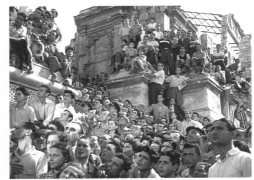
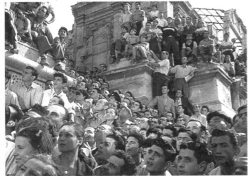
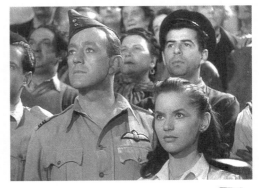

TREASURE IN MALTA (1963)

Bus Terminus, Valletta

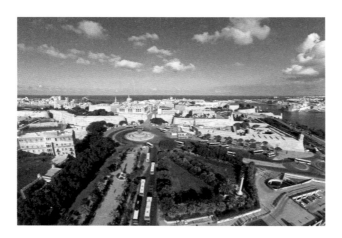

THE GIANT MALTESE CROSS decorating the long-lost Kingsway Gate overlooking traditional multicoloured Maltese buses, all neatly organized around the imposing Tritons Fountain, is a carefully choreographed postcard of Valletta in the 1960s: a Valletta which is no more. The buses have been replaced by modern ones, while the entrance to the city is now a Renzo Piano work of art. The scene is set for yet another chase sequence in which Tom (Aidan Mompalao de Piro) and Sukie (Marylu Coppini née Ripard) seek to rescue their father, abducted by a comic trio of crooks intent on nabbing the legendary golden statue of Calypso. Jiminy (Mario Debono), a local boy, becomes their sidekick and guide, as the children try to save the day. Like all the other films made by the Children's Film Foundation, *Treasure in Malta* is an enjoyable family adventure promoting values such as team work. However, having been generously supported by the Malta Tourist Board, *Treasure in Malta* practically became a two-hour advertising campaign, displaying stunning Maltese landmarks and traditions. Long before acknowledging or harnessing the modern concept of screen tourism, the Board understood the potential of showing Malta on-screen in a film that would reach over thirty countries and be dubbed in a dozen different languages. *Treasure in Malta* is nothing short of a time capsule and an evocative testament to the beauty of the Maltese islands. **✢Jean Pierre Borg**

Photo © Mark Cassar

Directed by Derek Williams
Scene description: The chase after Tom, Sukie and Jiminy continues
Timecode for scene: 0:32:58 – 0:34:11

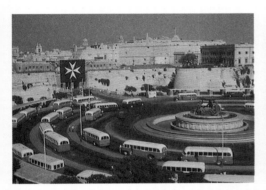 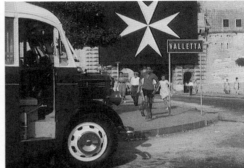

 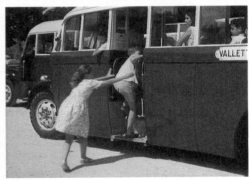

GIUSEPPI (1972)

LOCATION *Il-Mandraġġ, Valletta*

GIUSEPPI is the most successful film of Cecil Satariano's short-lived film-making career. The short, which features no dialogue, won awards in film competitions in Nagasaki, London, Cannes, Tokyo, New York, Lisbon and Hiroshima. Giuseppi Mallia, also known as *il-Futtru*, plays the eponymous crippled vagrant. Satariano cast Mallia after observing him on the streets of Valletta. As the story goes, Mallia had never seen a film before and when the director approached him he was unable to fathom what was being asked of him. Perhaps it is this naivety that makes his performance so absorbing. Although a fictional film, the inclusion of Mallia – his demeanour, his body, his clothes, his social surroundings – form a creative and tragic interpretation of his reality. Satariano's use of Valletta visually demonstrates the social stratification inherent in the capital city, with *Giuseppi's* finale taking place in an area more impoverished in comparison to the others that feature in the film. Known as *il-Mandraġġ*, the gridded streets imbue the scene with unease. Interestingly, in the 1970s Satariano was on the Board of Film Censors, and was also a film critic for one of Malta's leading English-language newspapers. More importantly, he published a book on amateur film-making in 1973. Entitled *Canon Fire: The Art of Making Award Winning Movies*, the book was commissioned by a British publishing company. In another aside, Mallia also attracted the attention of British director Mike Hodges, who gave him a bit-part in the Michael Caine vehicle *Pulp* (1972). **↝Charlie Cauchi**

Photo © Jean Pierre Borg

Directed by Cecil Satariano
Scene description: *A vagrant is stalked by a stranger through the streets of Valletta*
Timecode for scene: *0:15:00 – 0:19:53*

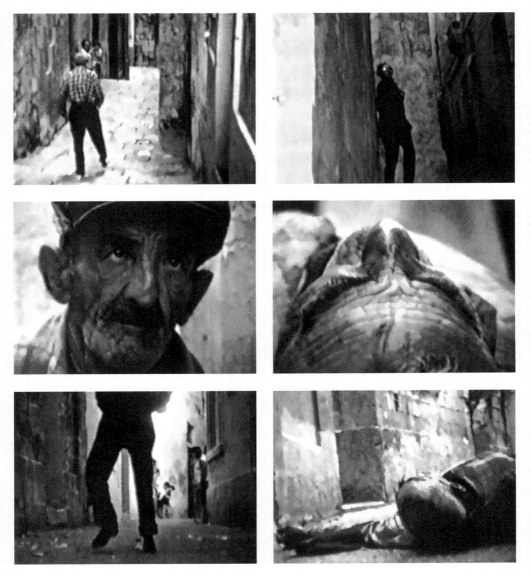

EYEWITNESS (1973)

Upper Barrakka Lift, Valletta

THE STORY OF THE BOY WHO CRIED WOLF takes a suspenseful twist in this British drama, filmed entirely in Malta. After 11-year-old Ziggy (Mark Lester) witnesses the assassination of a visiting dignitary, the film effectively functions as one prolonged chase sequence. While the island remains unnamed, used solely as an exotic milieu against which to set the screenplay, viewers are still treated to their fair share of the Maltese landscape. The camera careers across rugged seascapes and up steep limestone steps, though for many Maltese it is this scene that remains iconic: in a tense moment in the film, Ziggy manages to flee his assailants by entering the Upper Barrakka Lift. As his aggressors negotiate the narrow streets of the capital, Ziggy is framed trapped inside the menacing confines of the caged structure. External low-angle shots are added to exaggerate the lift's verticality. An intrinsic component of Valletta's urban fabric, the lift was originally built by the British in 1905, but by the time the film was released it was no longer operational and was eventually dismantled by the mid-80s. In 2012, UK and Malta based Architecture Project unveiled a renovated version of the lift, improving links between the Grand Harbour and Valletta. ❖**Charlie Cauchi**

Photos © Pauline Dingli (viewingmalta.com) / Stefan Starface

Directed by John Hough
Scene description: After witnessing an assassination attempt, Ziggy has to escape his assailants
Timecode for scene: 0:26:05 – 0:28:12

MIDNIGHT EXPRESS (1978)

Lower Fort St Elmo, Valletta

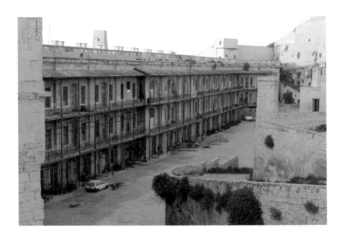

IN 1977 DIRECTOR ALAN PARKER transformed Fort St Elmo into a Turkish prison, creating a nightmarish vision of the republic's justice system. The film is based on the 'true' story of Billy Hayes, who, after being incarcerated on drug-related charges, managed to escape after five years. The Oscar-winning film's portrayal of the Turkish justice system rendered the country off-limits as a filming location. After visiting the island, Parker felt that Malta had the right cinematic look for the film, and the production relocated to the island for a total of 53 days. Malta appears throughout, bar a number of establishing shots of Turkey, which were taken by a second unit; the film-makers managed to gain permission on the pretence of shooting a cigarette commercial. While several locations were used, Fort St Elmo is the most prominently featured, standing in for Istanbul's Sağmalcılar prison. Oliver Stone's screenplay constructed a more harrowing depiction of prison life, with Hayes's (Brad Davis) character brutally victimized. Rather than a conventional prison setting, the historic fortification, impregnated with the legacy of the Order of the Knights of St John and ravaged by the 1565 Great Siege, adds a level of barbarism. The structure was mainly left untouched, with the exception of a few minor elements. Although Malta appeared on international screens, the film will always be associated with Turkey, where the film was banned because of its anti-Turkish rhetoric.
➷ *Charlie Cauchi*

Photo © Jean Pierre Borg

Scene description: Billy has been incarcerated in a Turkish prison for drug smuggling
Timecode for scene: 0:26:56 – 0:30:03

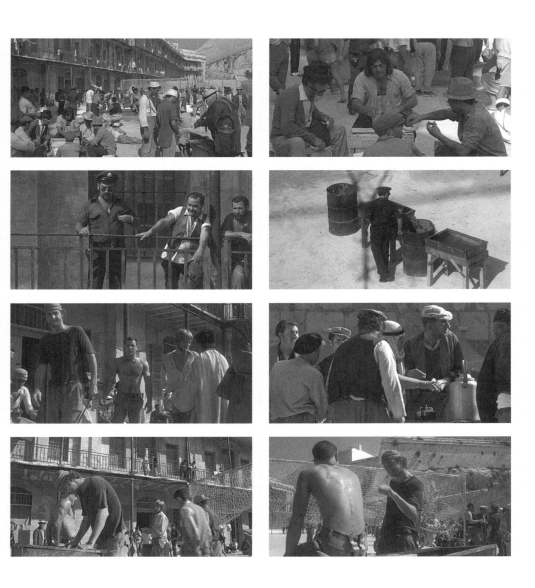

THE COUNT OF MONTE CRISTO (2002)

LOCATION *Grandmaster's Palace, Valletta*

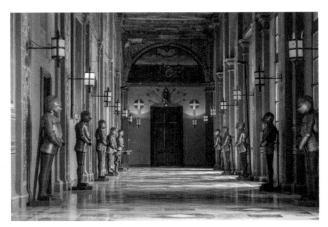

READERS FAMILIAR WITH DUMAS'S NOVEL *The Count of Monte Cristo* (1844 – 1845) know that immediately upon his rescue from the sea after escaping from Château d'If, Edmond Dantès introduces himself to his rescuers as a shipwrecked Maltese sailor. While Malta gets passing mention in this classic novel, two of the countless screen adaptations that have been created over the years were partly shot in Malta. The first was a 1998 TV miniseries starring Gérard Depardieu, while the other was the 2002 feature film directed by Kevin Reynolds. Santa Maria Tower on Comino was used to represent Château d'If; Bakery Wharf in Birgu stood in for the port of Marseilles; and St Paul's Square in Mdina for a carnival scene in Rome. It is here that Dantès (Jim Caviezel) wins the trust of Albert Mondego (Henry Cavill), the son of Mercédès (Dagmara Dominczyk) and Fernand (Guy Pearce). Part of his plan for revenge is to befriend Albert and gain access to his parents as the Count of Monte Cristo. The scene in the Grandmaster's Palace in Valletta shows Dantès hosting and befriending Albert. The grandeur and boundless wealth of the Count is attested by the frescoed entrance, the lush central courtyard and the iconic marble floor corridor flanked by original knight's armour and painted portraits of several Grandmasters of the Order of St John. The trap is set when, with Jacopo's (Luis Guzmán) help, the Count confirms that he can make it for Albert's 16th birthday celebrations in Paris. **↝Jean Pierre Borg**

Directed by Kevin Reynolds
Scene description: Albert Mondego visits Edmond Dantès at his Roman estate
Timecode for scene: 1:28:00 – 1:28:28

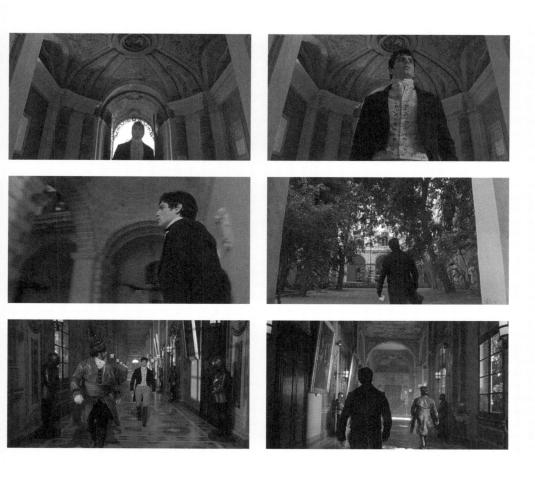

A DIFFERENT LOYALTY (2004)

LOCATION *St Ursula Street and its environs*

A DIFFERENT LOYALTY is a fictional account of Eleanor Brewer's 1967 memoir *Kim Philby: The Spy I Loved*. Directed by Marek Kanievska, the film is a co-production between Canada, the United Kingdom and the United States, and features Rupert Everett and Sharon Stone in the lead roles. The sepia tones signal a flashback, with this scene providing a visual explanation of Leo's (Everett) disappearance. We are transported back to Beirut in 1967, four years after Leo and Sally (Stone) are wed. While the film is framed by the Cold War, le Carré this isn't. But rather than focusing on the film's misgivings, its saving grace is the sumptuous production design and precise attention to detail. Yet again Malta doubles for the Arab world, matching the sophistication and glamour that were synonymous with 1960s Beirut. Taking into account the real events that the film is loosely based on, Philby – a double agent who defected to the Soviet Union in the 1960s – and his third wife Eleanor are said to have lived in a fifth-floor apartment on Rue Kantari, Ras Beirut. Here, St Ursula Street and its environs, with its limestone walls and labyrinthine narrow streets, make an elegant substitution. In contrast to earlier moments in the film, here the lived-in spaces of daily life have taken a sinister, dramatic turn. **Charlie Cauchi**

Directed by Marek Kanievska
Scene description: Leo recalls the events that led to his departure
Timecode for scene: 0:57:00 – 0:59:20

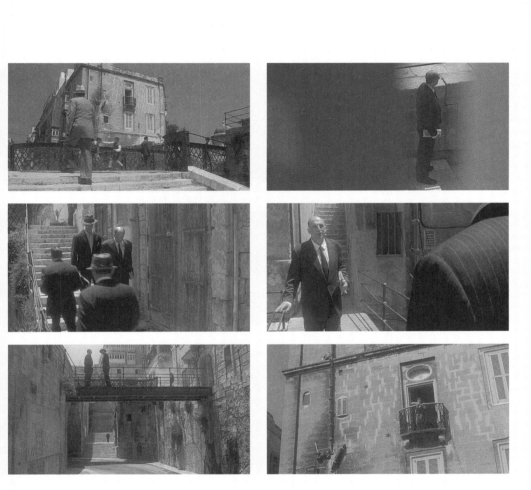

MUNICH (2005)

Republic Square, Valletta

IN MUNICH, Steven Spielberg reviews this dark chapter in world history, concentrating on the aftermath of the 1972 attack on the Olympic Games, where eleven Israeli athletes were taken hostage and eventually killed by the Palestinian terror group Black September. Rather than focusing on the event itself, *Munich* offers an exploration of Mossad's Operation Wrath of God and the mechanics of assassination. Featuring an array of international stars, the film traverses the globe, with the action taking place in a number of countries including Germany, France, Rome, Israel and Greece. In reality Malta is used to double for many of these places, using a mixture of actual locations and constructed sets. As tiny as Malta may be, through the contribution of the production designer and cinematographer, physical and temporal travel is achieved. A patchwork of eastern and western influences, the production effectively teases out Malta's Islamic and European influences. Using this scene as an example, Rick Carter's production design transforms modern-day Valletta into 1970s Rome. Andreas (Mortiz Bleibtreu) introduces Avner (Eric Bana) to Tony (Yvan Attal) against a backdrop of Italian iconography and style. From the Martini logo to the baroque architecture and sophisticated garb of the city-dwellers, Carter effectively articulates a differentiation of space. This is compounded by Janusz Kaminski's cinematography, which assigned a different type of film stock to each city and period, thereby bestowing each physical and temporal space with its own distinctive colour palette and texture. In this case, Rome's warmth contrasts to the Palestinian refugee camp, which is rendered almost colourless by bleach bypassing the image. Kaminski also gives the scene a voyeuristic feel; his use of zooms is a direct nod to the espionage films of the 1970s. **➡Charlie Cauchi**

Photo © Stefan Stafrace

Directed by Steven Spielberg

Scene description: Andreas introduces Avner to Tony in Rome

Timecode for scene: 0:30:30 – 0:32:32

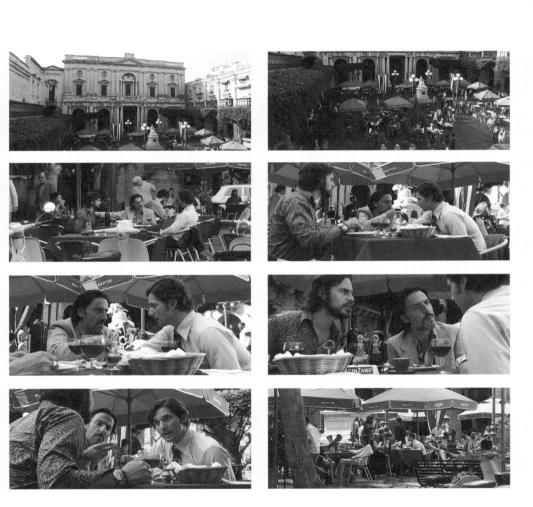

AGORA (2009)

Valletta Ditch, Valletta

LATE-FOURTH-CENTURY ALEXANDRIA is brought to life in this cinematic exploration of philosophy, political strife and religious conflict in the Eastern Roman Empire. Co-written and directed by Alejandro Amenábar, the life and death of Hypatia of Alexandria, played by Rachel Weisz, is reimagined for the twenty-first century. The most important female philosopher of the ancient world, Hypatia was highly regarded but her life came to a very tragic end. In *The Making of Agora*, Amenábar reveals that in 2004 he was anchored on a boat off the coast of Malta, 'and for the first time I saw the Milky Way, and I was overwhelmed [...] I wanted to convey this'. In fact, while *Agora* is a Spanish film financed by Spanish money, the production relocated to Malta for its entirety. Shooting commenced in 2008 and lasted for eleven months, strengthening Malta's reputation for first-class craftsmanship and as an ideal backdrop of the epic genre. The polyglot community of Alexandria is meticulously refashioned on a grand scale, built from scratch by Maltese artisans. The intellectual life of Alexandria is an elaborate medley of papyrus and stucco, with Guy Hendrix Dyas's production design allowing for a minimal amount of CGI. *Agora*'s colour palette is said to have been inspired by the Fayum mummy portraits, giving the picture an overall gentle and naturalistic look. This scene illustrates the sheer ambition of the project. Sets were also constructed at other sites across the island, including Fort Ricasoli and Marsaxlokk. **↝Charlie Cauchi**

Photo © Jean Pierre Borg

Directed by Alejandro Amenábar
Scene description: The Jews are expelled from Alexandria
Timecode for scene: 1:17:34 – 1:18:06

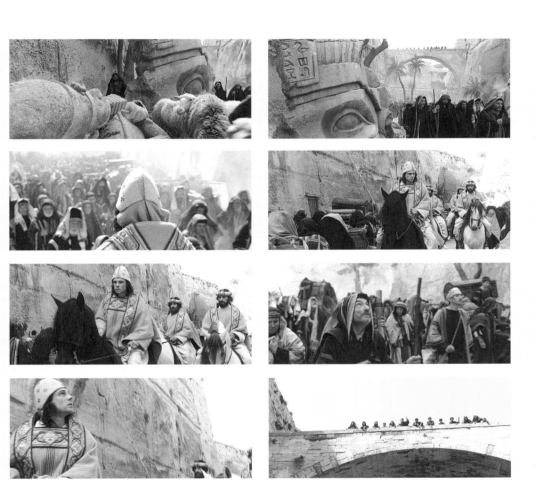

PLANGENT RAIN/DAQQET IX-XITA (2010)

PLANGENT RAIN was one of the first films to be funded by the state through the Malta Film Fund. Looking to the city for artistic inspiration, Kenneth Scicluna's black-and-white short is a moody examination of insecurity, loss and urban decay. Inspired by one of Valletta's most infamous sites, the majority of the film is set in Strait Street – a secondary street also known as The Gut, due to its 'colourful' history as a site for prostitution and general misdoings. It is a pertinent space to represent on film, especially given that the area has recently gone through a heavy process of regeneration. Scicluna's Valletta is bereft of auberges and grandeur. Rather, the squalor of the capital is favoured over the opulence of say Republic Street or Merchants Street. The film also places the narrative in a colonial context, while also drawing from Soviet director Grigori Kozintsev's 1964 production of Shakespeare's *Hamlet*. For all of Valletta's ordered arrangement, this rectilinear cityscape is reconfigured to suit the psychological landscape of our main protagonist, the unnamed boy, played by Sean Decelis. In doing so, the film also subverts many of the cinematic representations of the capital. **⟿Charlie Cauchi**

Photo © Jean Pierre Borg

Directed by Kenneth Scicluna
Scene description: The boy wanders the rainy streets of Valletta
Timecode for scene: 0:05:52 – 0:08:03

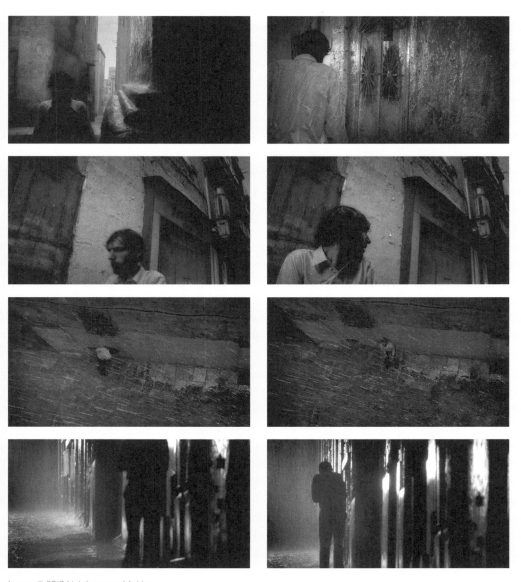

THE DEVIL'S DOUBLE (2011)

LOCATION *St John Street, Valletta*

AS IS THE CASE with many of the productions featured in this book, the Maltese landscape masquerades for another. In this instance, the other is Iraq circa 1987, under the rule of Saddam Hussein. Iraq's cinematic substitution is achieved through the aesthetic manipulation of a number of interior and exterior locations, coupled with the incorporation of archival footage into the overall fabric of the film. Capitalizing on Malta's chameleonic ability, the production exploits its Arabic attributes and enhances them through the use of props and editing techniques. But somewhere in-between the arid landscapes, imposing monuments and the tawdry, gaudy interiors favoured by Uday Hussein, Malta is granted its own moment of screen time. While Malta's identity is eradicated throughout most of the film by the addition of props, this scene draws attention to Malta's national specificity and the island's Europeaness by incorporating key signifiers into the frame. It is not a matter of what to conceal, but what to reveal. A crucifix here, a red telephone box there; all elements act as shorthand to reinforce Malta's ties to the West. Rather than elaborate sets, the location remains untouched – even the contemporary street signs have remained in situ.•*Charlie Cauchi*

Photo © Stefan Stafrace

Directed by Lee Tamahori
Scene description: Latif has escaped from Uday Hussein, fleeing Baghdad for Malta
Timecode for scene: 1:32:14 – 1:32:55

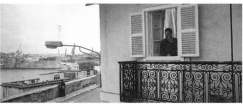

 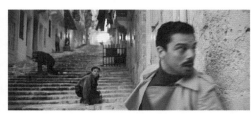

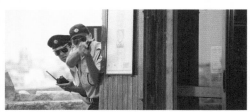 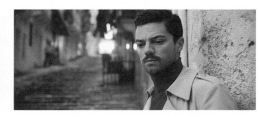

WORLD WAR Z (2013)

LOCATION *St Dominic Street, Valletta*

A MONSTER MOVIE for the twenty-first century, *World War Z* proffers a post-apocalyptic travelogue, with Gerry Lane (Brad Pitt) driving the story forward as he travels the world in search of the cause of this global pandemic. This geopolitical thriller is based on Max Brooks's 2006 novel and produced by Pitt's production company, Plan B. Plagued by rewrites, reshoots and a spiralling budget, the film was released almost two years after commencing principal photography in Malta in the summer of 2011. The island was chosen to depict a zombie-infested Israel, where a walled city has been created to separate the humans from the flesh-eating undead. Palestinians and Jews unite behind a fortress once intended to separate them, but ironically it is their peace-loving chants that send the zombies into a feverish melee, as they attempt to scale the heights of the structure, clambering one on top of the other to create a tower of decaying, rabid flesh. Unlike the zombies that inhabit the world created by George Romero's *Night of the Living Dead* (1968), or even AMC's *The Walking Dead* (2010-), these creatures don't lumber and groan; rather, their bodies writhe in an unconventional manner and sprint down narrow passageways hurtling towards their prey. Approximately 900 local extras were used to bring this nightmare scenario to life, with scenes set in the backstreets of the capital city.
↝*Charlie Cauchi*

Photo © Jean Pierre Borg

Directed by Marc Forster
Scene description: The undead run riot through the streets of Israel
Timecode for scene: 1:03:53 – 1:04:10

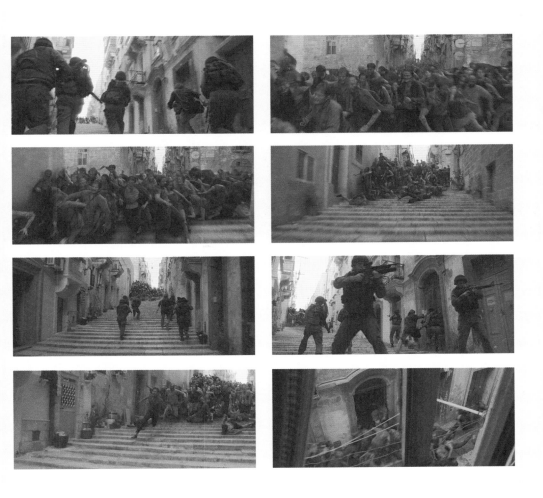

THE CUT (2014)

East Street, Valletta

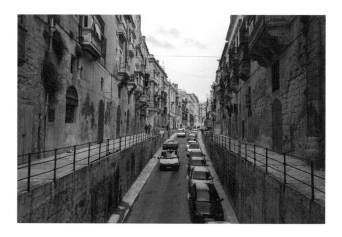

THE CUT, which premiered at the 71st Venice Film Festival, follows the fictional story of Nazaret (Tahar Rahim), an Armenian blacksmith who is separated from his wife and twin daughters during the 1915 violence against Armenians in the Ottoman Empire. After a botched execution leaves him mute, Nazaret wanders aimlessly in the desolate landscape witnessing starvation and death until he is taken in by a soap maker from Aleppo who sneaks him into town. Footage shot in Jordan depicting a complex scene was damaged during post-production. For logistical reasons, it was more practical to reshoot the scenes in Malta. This scene is set in Aleppo in November 1918, when the British liberate the city. Nazaret and Krikor (Simon Abkarian), a newly befriended Armenian refugee, are bystanders while the Turks are being escorted out of Aleppo. The tables are turned when the angry Armenians seek revenge on the Turks, and their exile from Aleppo degenerates into a violent stoning. Krikor fervently bids Nazaret to join in the aggression but Nazaret is stopped in his tracks as he witnesses a child being hit in the face. While this scene was the only one filmed in Malta, the environs of East Street in Valletta mesh inconspicuously with the rest of the Aleppo scenes shot in Jordan. It is in Aleppo that Nazaret gets to discover that his daughters could still be alive and embarks on a journey across the globe to find them. **⇢Jean Pierre Borg**

Photo © Robert Racaru

Directed by Fatih Akin
Scene description: The Turks are driven out of Aleppo
Timecode for scene: 1:03:30 - 1:04:49

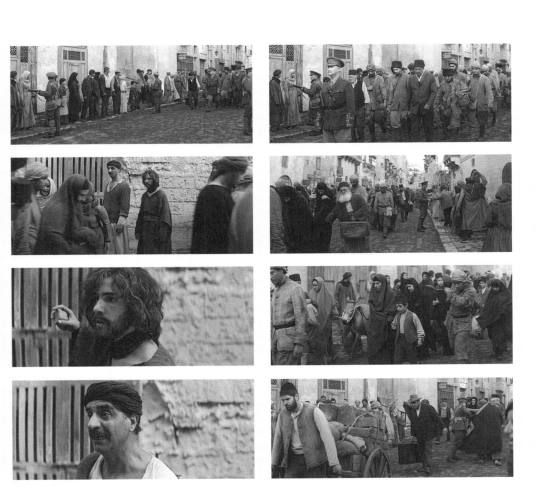

TEXTURED SPACES IN THE MALTESE FIGHTER

Text by
MONIKA
MASLOWSKA

THE MALTESE FIGHTER (Arev Manoukian, 2014), shot mainly in the city of Valletta, resurrects urban spaces exposing emotions, movements and surfaces. As the narrative unfolds, the film goes beyond the visual and the aural, alluring the audience immediately to the world of Valletta in 1971. And what the audience discovers is a tactile association heightened by a play of shadows as the afternoon light retreats itself from the stone surfaces lying still in a monochrome light awaiting the night.

The sensuous attention to detail was a conscious choice by the film director, Arev Manoukian, whose understated visual interpretation comes from the smallest and the finest detail captured by the camera. And this is how it is presented to the audience: a soft, de-saturated and faded effect, which gives a delicate feel that is in tune with its filmic space of the city; a palimpsestic, multi-layered city of light and shadow. A city of man-made cubic fortifications and walls juxtaposed with vernacular buildings, forming an intricate composition of aesthetics and architecture: the smoothness and the roughness.

The Maltese Fighter contributes to our understanding of the city while at the same time addressing two interrelating key issues:

fascination with the city's sixteenth-century baroque architecture and an exploration of its unchanged spaces.

The second issue is the city's subsequent transformation and embellishment from the early 2000s, with major restoration work bringing the city back to its former beauty, providing a new, or at least, a fresher context for a contemporary European capital city and its economic resurgence.

It is not unsurprising that Valletta was chosen as the backdrop for *The Maltese Fighter*. The film tells the story of a struggling single father and boxer from Valletta at the peak of his career, Carmelo (Malcolm Ellul), who is forced to join a corrupt underworld so as to provide for his only son Giuseppi (Nico Fenech/Keith Richard). Carmelo's fast moves and hard strikes lead him to numerous victories, and even though his boxing career does not make much money, it is rewarding in other ways. He is an inspiration to the city and to his son. Unfortunately everything comes at a price and as the narrative oscillates between a father's self-sacrifice and redemption, between the opacity of the vertical textures and the vertical horizontal strands, between the tactility of spaces and materiality of surfaces, between a montage of images at dawn and sounds at dusk, the audience is able to identify not only with the world but also with the consequence of Carmelo's choices.

The revelation of Carmelo's mental state is supplied in small doses as the connections between events are filled in by implication. The film is bursting with experiences of shape, colour, depth and decor, as is Carmelo's rugged soul. He is responsive to the texture of the places he inhabits, and the audience responds to him. The wonderful cinematography achieved by the Director of Photography, Matthew Taylor, offers an aesthetic grittiness in which textured spaces embody the mental state of the protagonist. ✠

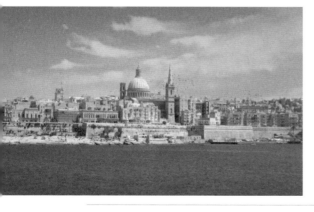

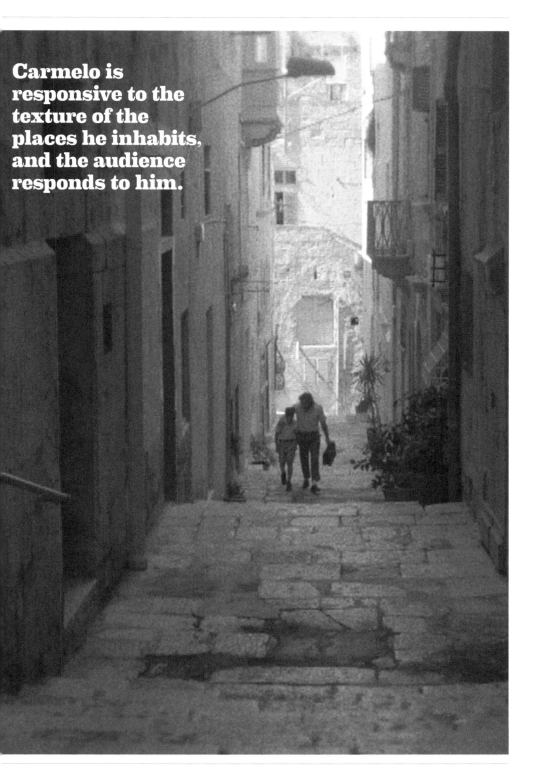

Carmelo is responsive to the texture of the places he inhabits, and the audience responds to him.

N

LOCATIONS MAP

MALTA

MELLIEHA

RABAT

MALTA

MALTA LOCATIONS
SOUTHERN HARBOUR

VALLETTA

THEY WHO DARE (1954)

Dock No. 1, Cospicua

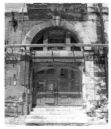

LEWIS MILESTONE was no stranger to directing war-themed films, with titles like the 1930s cinematic masterpiece *All Quiet on the Western Front* credited to his name. According to Dirk Bogarde's official autobiography, the actor couldn't pass up the opportunity to work with Milestone and therefore accepted the part of Lieutenant Graham in the British-backed film *They Who Dare*. Focusing on World War II, *They Who Dare* was by no means as highly regarded as Milestone's previous war films: critics even went so far as to dub the film 'How Dare They?'. Lt. Graham hand-picks a group of British and Greek commandos, leading them to raid a German airfield on the island of Rhodes. The majority of the exteriors where shot in Cyprus, but a few of the film's key scenes were also shot on location in Malta. This scene in particular was filmed at the Cospicua Dock No. 1 and although the dock remains notably untouched, with hardly any alterations made to the site, it stands in for Cairo. World War II films were a staple of the 1950s post-war cinema, but many titles were made in black and white as they were relatively cheaper to make. *They Who Dare* however was produced in colour. If we look at Malta's cinematic back catalogue, the film appears to be the first foreign feature to show Malta in colour. ➻*Charlie Cauchi*

Photos © Stefan Stafrace / Jean Pierre Borg

Directed by Lewis Milestone
Scene description: Lieutenant Graham meets his crew in Cairo
Timecode for scene: 0:06:43 – 0:07:11

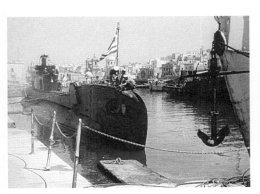 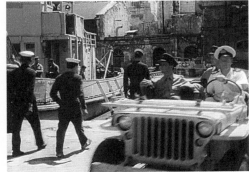

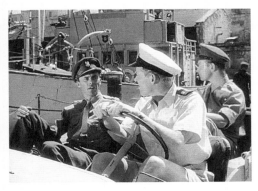 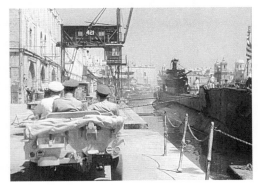

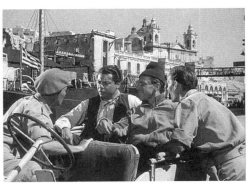 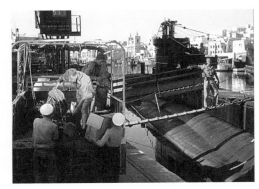

RAISE THE TITANIC (1980)

LOCATION *Film Studios, Kalkara*

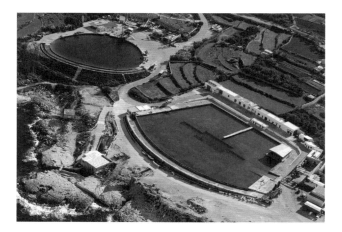

BASED ON THE 1976 NOVEL by Clive Cussler, *Raise the Titanic* was a box office flop and financial disaster, going roughly $16 million over budget. When the film's producer Lord Lew Grade passed away in 1998, his obituary quoted his response to the picture: 'It would have been cheaper to lower the Atlantic Ocean.' Sailing past the disastrous business outcomes, there is some merit to the film, specifically the *Titanic* itself. This is the first feature film about the *Titanic* to be shot in colour. It also features one of the most detailed models of the vessel. A 55-foot-long, 12-foot-high replica of the *Titanic* was brought from the United States to the studios in Kalkara and allegedly cost millions to construct. This spectacular moment when the ship breaks the surface of the water was shot in a deep water tank, which was purposely built at the studios in Kalkara. Unfortunately, the replica has fallen into a state of disrepair after years of neglect and weather worn damage. **⤳ Charlie Cauchi**

Directed by Jerry Jameson
Scene description: The Titanic is raised
Timecode for scene: 1:16:42 – 1:24:31

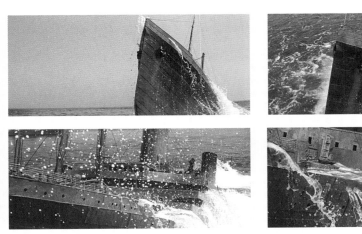
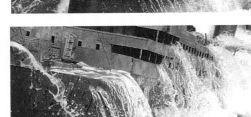
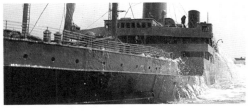
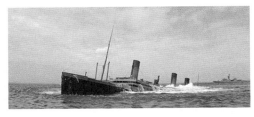
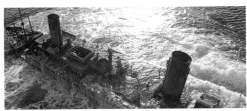
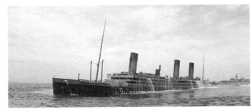

CUTTHROAT ISLAND (1995)

Bakery Wharf, Vittoriosa Waterfront

WHEN THE DEFUNCT CAROLCO PICTURES set out to produce *Cutthroat Island*, there were high aspirations that this film would revive the pirate genre. However, it was this film that dealt the final blow to one of the biggest independent production companies of the 1980s and early 1990s, which had previously raked in over $2 billion from movies like *Rocky* (John G, Avilsden, 1976), *Terminator 2: Judgment Day* (James Cameron, 1991) and *Basic Instinct* (Paul Verhoeven, 1992). Indeed, at one point *Cutthroat Island* held the dubious honour of being Hollywood's biggest flop. The film cost $100 million to produce, promote and distribute, but recovered just $11 million at the international box office. One of the film's action sequences was shot along the aptly titled Bakery Wharf in Vittoriosa. Clearly visible a number of times during this sequence, the naval bakery, built in the 1840s, supplied the Royal Navy's Mediterranean fleet stationed in Malta with its daily requirements of bread and biscuits until the 1950s. Standing in for the busy Port Royal in Jamaica, the approximately 350-metre-long wharf had been totally transformed with old replica ships and galleons brought over to Malta specifically for this scene. In an attempt to escape British troops out to capture the wanted pirate, Morgan Adams (Geena Davis) and her newly acquired slave William Shaw (Matthew Modine) flee on a horse-drawn carriage. When the mounted troops pursuing them fail to catch up to the runaways, ships docked in the harbour are instructed to fire their canons. The facade along the quay is riddled with cannon fire, ending the scene with a mass of explosions.
❖Jean Pierre Borg

Photo © Jean Pierre Borg

Directed by Renny Harlin
Scene description: Morgan Adams, a wanted pirate is chased through Port Royal
Timecode for scene: 0:25:02 – 0:28:52

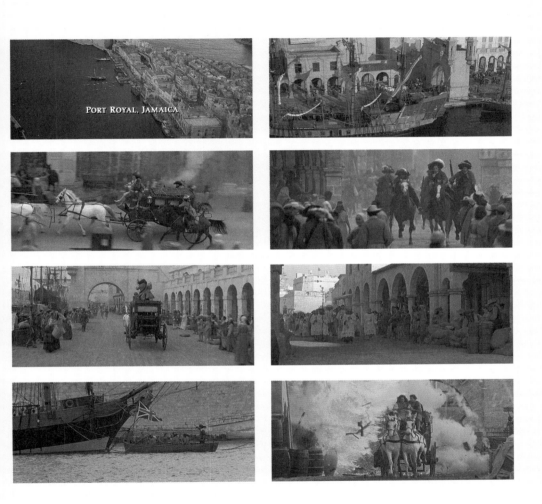

GLADIATOR (2000)

Fort Ricasoli, Kalkara

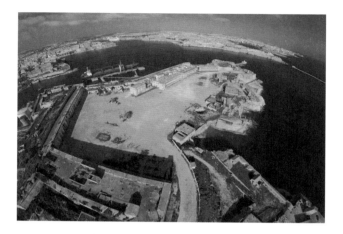

GLADIATOR, the Oscar-winning Roman epic, used Malta for large parts of principal photography. The massive (70,000 m²) Fort Ricasoli was the location chosen by director Ridley Scott and his designer Arthur Max to build the majority of the vast sets that created the ancient city of Rome – most memorably the set for the Coliseum, the backdrop for the film's most dramatic sequences. Fort Ricasoli was originally constructed in the late seventeenth century by the Order of St John on one of Malta's most strategically important locations and acted as one of the key defensive positions protecting the Grand Harbour from attack. *Gladiator* was the first major feature film to take advantage of the Fort's potential as a sprawling, sun drenched backlot – and the success of that film paved the way for other movies to follow suit over the next decade (Wolfgang Peterson's *Troy* in 2004 and Alejandro Amenábar's *Agora* in 2009). Gladiator redrew the boundaries of how CGI could be used in cinema, seamlessly blending live-action photography with enhanced photo realistic CGI backdrops. There are few better examples of this than the famous Coliseum scenes where Maximus (Russell Crowe) enters the arena for the first time. The set that Scott and Max built at Fort Ricasoli was huge – one of the largest location sets ever built – yet only a fraction of it appeared in the final film. Fort Ricasoli didn't steal all the *Gladiator* glory however. Other locations included Couvre Porte in Vittoriosa, as well as the Valletta Ditch where Maximus discovers he has been betrayed and is recaptured towards the climax of the film. ↬*Jake Mayle*

Photo © Mark Cassar

Directed by Ridley Scott
Scene description: Proximo's gladiators enter the Roman arena
Timecode for scene: 1:25:41 – 1:30:29

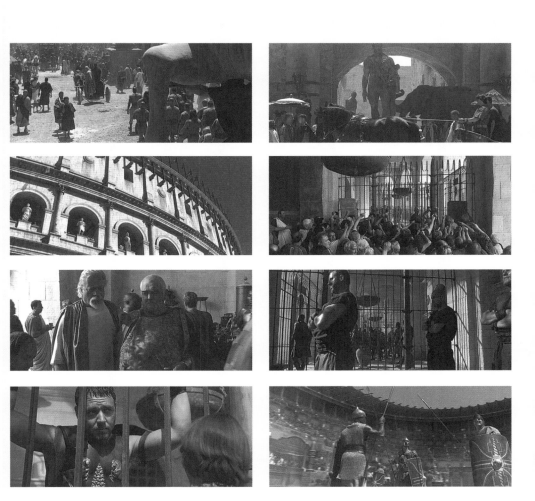

FROM V. TO WORLD WAR Z

The Inhabited Plain

Text by
GUILLAUME
DREYFUSS

***The inhabited plain; the peninsula
whose tip is valletta, her domain.***
– Thomas Pynchon, *V.* (p.434)

FROM LITERARY FICTIONS to the moving image, Malta, and Valletta in particular, have inspired writers, illustrators and movie directors to represent, portray and often camouflage the well-known image of the city in order to complement their artistic production. Early-nineteenth-century travelogues abound with descriptions of a city that ranged from idyllic to primitive according to the travellers' expectations and biases. These nevertheless continuously enriched the appreciation of Valletta's fabric and contributed to its appeal far beyond the Mediterranean shores. The importance acquired by visual productions over recent decades has only further increased the impact of these images on our perception and appreciation of the built environment. It was Paul Valéry who perhaps best summarized this potential when he probed that if Plato had reduced the mouth of his grotto to a tiny hole and applied a sensitized coat to the wall that served as his screen, by developing the rear of the cave he could have obtained a gigantic film, and heaven knows what astounding conclusions he might have left regarding the nature of our knowledge and the essence of our ideas.[1]

Images of visionary cities have always fascinated the public, film-makers and architects alike. Even though these dreams have often been demoted to the domain of science fiction, they provide the opportunity to study and develop a city with infinite possibilities, a 'future city such that the latter [future city] is seen as the

technological development, refinement, and replacement of the former [historical city]', in what Elizabeth Grosz qualified as a 'pervasive fantasy of disembodiment' (p.82). Whether it is the descriptions of Valletta in Pynchon's *V.* (1963) developed in the light of his reading of Wittgenstein; or the visions of an apocalyptic cityscape in Max Brooks's *World War Z* (2006), which saw Marc Forster transform Valletta into an exotic destination (*World War Z*, 2013), these visions help us to question our own perception of the spaces we live in, as a result of their abstraction, altered dimensions, or the play between reality and imagining that is the catalyst for the evolution of identity.

Looking at Valletta and Malta's filmography we can discover an abundance of films which used the city as a backdrop, in timeframes ranging from antiquity to post-alien invasion futures, without necessarily resorting to a *disembodiment* of the city's nature. In his writings, Perec questions our ultra-mediated existence which seems to go by, using proxies and leaving us yearning for exoticism. In asking '*où est notre espace*? (where is our space?)' he invites us to probe 'the banal, the quotidian, the obvious, the common, the ordinary, the infra-ordinary, the background noise, the habitual.'[2] He echoes here the daydreaming of Bachelard in his *Poetics of Space* (1958), but also Walter Benjamin's *One-Way Street* (1979) idea of getting lost. It is the idea of back-and-forth, of temporal and spatial dynamism, that is fascinating in the relation between a city and a film location.

When Valletta is transformed through CGI to embody Alexandria in Oliver Stone's *Alexander*

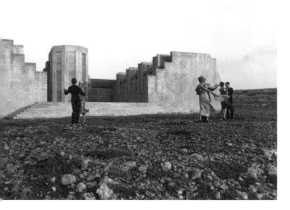

(2004), if this *body* can exist virtually, the viewer is willingly accepting this representation as reality, within the framework of the movie, often oblivious to the initial setting of the action as to its mediated proxy. In this case only the outlines, the shoreline and the skyline, of the city were used as the skeleton for the build-up of computer-generated images, with the buildings of Alexandria placed behind the images of the fortifications. The nature of the city has little influence or relevance in the narratives contained in the movie. However, in the case of *Munich* (Steven Spielberg, 2005) and *World War Z* (Marc Forster, 2013), the presence of the fabric of the city is much more manifest. It is here that we can observe what Maffesoli described as 'the shift from an aesthetic of representation to an aesthetic of perception' (*The contemplation of the world*, Minneapolis, MN: University of Minnesota Press, 1996, p.14). Cinema operates this shift through the moving image, first, but also through the careful selection of locations. Through the crafting of selected viewpoints, it often suggests the continuity of the landscape beyond the frame of the screen. It also relies on our limited vision, which is in turn compensated for by the brain, extrapolating a reality based on our understanding of the movie's context. This can only operate though, through the careful selection of the filming locations.

The architecture of Valletta lends itself to a varied array of movies. This is certainly due to the light, which is versatile yet always presents a specific intensity – as vividly described by Pynchon: 'light that afternoon produced a "burn" between whites and blacks: fuzzy edges, blurrings.

White was too white, black too black' (p.446), but also to the very fabric of the city, with its grid-iron urban plan, its steep streets and terraced roofs. It is in a way the Renaissance's aspiration to a perfect city and its subsequent developments that have allowed its filmographic potential.

It is, however, difficult to envisage location-scouting as the anticipation of any architectural *ekphrasis* to be revealed in a movie. Nonetheless cinema's contribution to the understanding and appreciation of space and of the city in particular is not to be discarded. The specific cinematographic vision substitutes itself to ours and offers us a world according to our desires, as Godard explained in the opening moments of *Le Mépris* (1963), misquoting André Bazin in lieu of Michel Mourlet. Although outside Valletta, it is perhaps Emidio Greco's *L'invenzione di Morel* (*Morel's Invention*, 1974) which, from a local perspective and before computer technology, best exemplifies the close relationship between cinema, architecture and the imaginary, mixing local arid landscape with a seemingly art deco architecture as backdrop to a science fiction narrative. There exists for architects a potential to explore their place of work, their backyard or their city differently through the cinematographic lens. Beyond the oft discussed issues of real and virtual, it is the alternative architectural journey provided by the moving image that is remarkable. Moholy-Nagy – who stopped by the islands briefly in the summer of 1933 together with the likes of Le Corbusier, Otto Neurath and Alvar Aalto[3] – had already recognized this potential for cinema, and photography, to generate new forms of perception of space, but also of time, movement and light (p.377). Valletta's rich history of contribution to narratives and fictions is, so far, an uncharted territory which potentially allows envisaging a future city beyond the traditional boundaries of the urban realm. ✥

NOTES

1. The Centenary of Photography trans. Roger Shattuck and Frederick Brown (in Classic Essays in Photography, Alan Trachtenburg (ed.), New Haven, CT: Leete's Island Books 1980), p.197.
2. L'Infra-ordinaire (Paris: Le Seuil, 1989), p.11
3. Henry Dietrich Fernandez, "Le Corbusier. Towards the origins of architecture, in The Founding Myths of Architecture, K. Buhagiar, G. Dreyfuss, J. Bruenslow (eds.) (London: Artifice, 2015) p.133

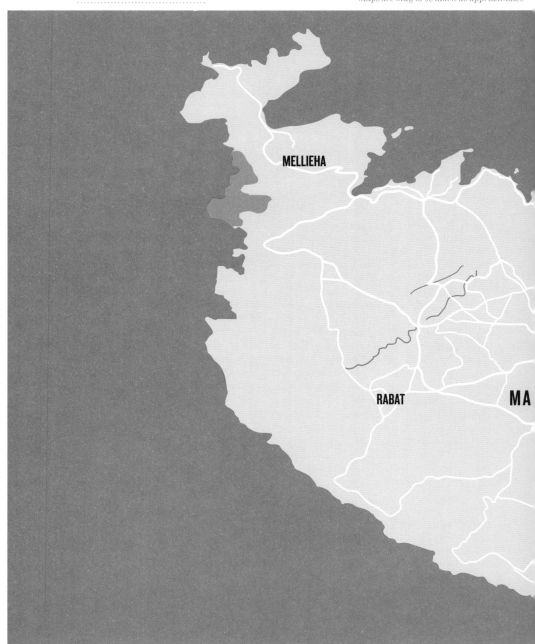

MELLIEHA

RABAT

MA

MALTA LOCATIONS
NORTHERN HARBOUR

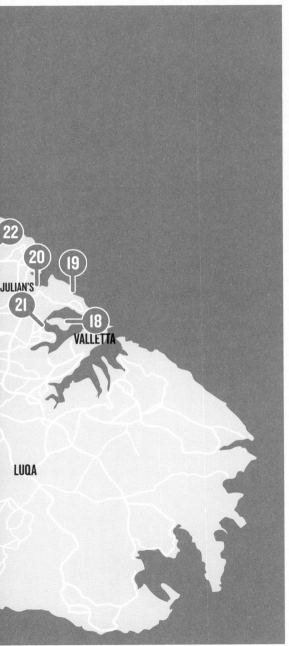

18.
HELL BOATS (1969)
Fort Manoel, Manoel Island, Gżira
page 52

19.
THE CAGE/GAĠĠA (1971)
Ghar id-dud, Sliema
page 54

20.
PULP (1972)
Balluta Buildings, Balluta Bay, St Julian's
page 56

21.
CHARAS (1976)
Ta' Xbiex Waterfront, Ta' Xbiex
page 58

22.
I WAS, ALREADY/KONT DIĠA' (2009)
Australia Hall, Pembroke
page 60

HELL BOATS (1969)

LOCATION *Fort Manoel, Manoel Island, Gżira*

EARLY ON IN *HELL BOATS*, Vice Admiral Ashurst (Moultrie Kelsall) briefs LtCdr Tom Jeffords (James Franciscus), on the very bleak scenario being faced by the Allies. He tells Jeffords, 'Malta is the hinge on which the war can turn and it will be your job to see that it turns our way', as he posts him on Dragonfly, Britain's Motor Torpedo Boat (MTB) base in Malta. Standing in for the British base is Fort Manoel, a fort built in the late eighteenth century by Grandmaster Manoel de Vilhena. During World War II, the fort was equipped with an anti-aircraft battery and consequentially was the target of numerous bombings, which partially destroyed various parts of the fort including the chapel dedicated to St Anthony of Padova in which Grandmaster Manoel de Vilhena is said to have been buried. War damage was still very visible when *Hell Boats* was shot and in some instances was used to the production's advantage. This is the case in one scene where smoke is spotted coming out of the half destroyed chapel. It was only in 2001 that major restoration works were undertaken, which included the rebuilding of the chapel. *Hell Boats* made extensive use of the various spaces within the fort including the parade ground, various interiors, as well as the seaward baroque gate, facing Valletta. The flight of steps built into the local limestone, which lead all the way down to the shore and was dressed with barbed-wire entanglements, provided striking access to the MTBs docked in the harbour.

➺ Jean Pierre Borg

Photo © Mark Cassar

Directed by Paul Wendkos
Scene description: A tour of Dragonfly, Malta's MTB Base
Timecode for scene: 0:09:54 – 0:17:34

 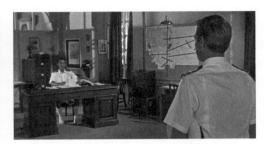

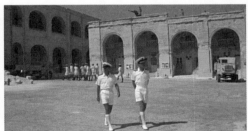 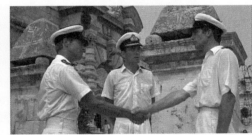

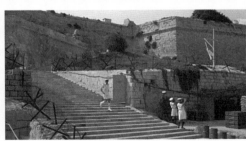 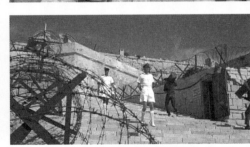

THE CAGE/GAĠĠA (1971)

Għar id-dud, Sliema

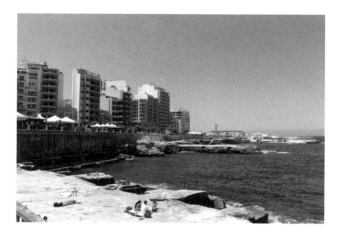

GAĠĠA makes for an interesting case study, not simply because it was made solely through local involvement and funded by the film-makers themselves, but because it was one of the first films to be produced in its native language. *Gaġġa*'s *mise-en-scène* effectively conveys the timeframe in which the film is set. Many of the spaces that the main protagonist Fredu (Ray Camilleri) inhabits at the beginning of the film are replete with Catholic signifiers, his surroundings illustrating the power of the Church. The religious iconography is minimized when Fredu moves to the town of Sliema, and the country closer to independence. Sliema also offers a clear contrast between the film's rural and urban settings. While both inflict a sense of displacement and exile on our main protagonist, Sliema is awash with affluent professionals and material effects. The appearances and mannerisms of the characters also change, with the townspeople of Sliema becoming more anglicized. It is not coincidental that names are modified, with Fredu, much to his dislike, called Fred or Freddie by his colleagues. Besides names, language also changes, with a marked difference in intonation and pronunciation between the two.
⊷ Charlie Cauchi

Photo © Jean Pierre Borg

Directed by Mario Azzopardi
Scene description: Fredu moves to the city of Sliema
Timecode for scene: 0:51:33 – 0:51:51

PULP (1972)

LOCATION *Balluta Buildings, Balluta Bay, St Julian's*

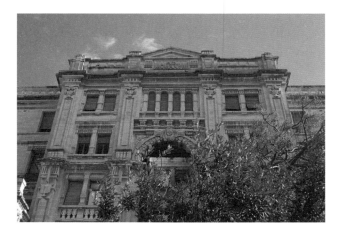

SOON AFTER THE HUGE SUCCESS of *Get Carter* (1971), Mike Hodges, Michael Caine and Mike Klinger set up Three Michaels Film Productions and set off to produce *Pulp*. Being more of a dark comedy, this second outing was very much different in tone to their first film and didn't receive the immediate acclaim of *Get Carter*. However, over the years there has been an increasing appreciation for this film, granting it some sort of cult status. The opening scene of *Pulp* sets the mood for the film and introduces us to the main character Mickey King (Michael Caine). King makes a living by churning out a string of violent, sexually charged noir novels with titles like 'The Organ Grinder' under an array of pen names like Les Behan. This fact is immediately introduced to the viewer as King arrives to collect a freshly typed manuscript from a typing pool at the Polyglot building. Set in front of a small square on the Sliema coastal road, Balluta Buildings are in fact one of the few art nouveau buildings in Malta. These buildings are the epitome of the 1920s, set in three blocks and six storeys high, they were at the time of shooting, one of the few 'high-rise' buildings in Malta. Outside the Polyglot, we're introduced to a thug, 'The Beautiful Thing' (Joe Zammit Cordina), who is clumsily tailing Micky in the most conspicuous of ways. His efforts at blending in are totally thwarted when the loud taxi driver (Charles Thake) requests his help to push the car. **⟶ Jean Pierre Borg**

Photo © Jean Pierre Borg

Directed by Mike Hodges
Scene description: Mickey collects his latest novel from a typing pool
Timecode for scene: 0:03:32 – 0:08:51

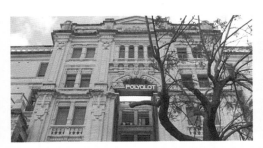

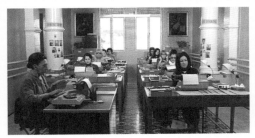
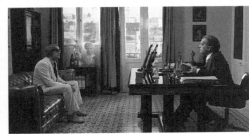

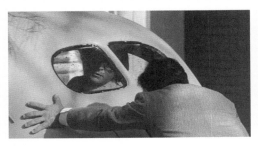
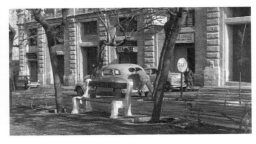

CHARAS (1976)

BOLLYWOOD EMBARKS on a scenographic tour of Malta in this melodic fantasy sequence. Highlighted here is a song and dance number entitled 'Raja Na Ja Dil Todke'. It provides a momentary pause from a nefarious plot of drug deals, blackmail and embezzlement. True to the *masala* genre of Hindi cinema, *Charas* blends action, adventure, music, romance and comedy together, while functioning as a vehicle for two prominent stars. Leading Bollywood duo Dharmendra (Suraj Kumar) and Hema Malini (Sudha) appeared in over forty films together, with *Charas* marking their sixteenth outing as the romantic hero and heroine. The narrative flow veers off the path somewhat to take in the sights and sounds of the island, where Malta is framed as a wealthy wonderland perfect for luxury travel. No doubt that the picture, besides bringing inward investment, would have been a useful way to market Malta further afield. The film's representation is characteristic of the outsider's vision of Europe, merging the ancient with the modern. This scene in particular is constructed on tourist iconography such as the *Karozzin* (a traditional horse-drawn carriage). Even Malini's red-and-white outfit is a sartorial nod to the isle. **⤙Charlie Cauchi**

Directed by Ramanand Sagar
Scene description: *A romantic musical interlude between Suraj Kumar and Sudha*
Timecode for scene: *1:27:28 – 1:28:16*

 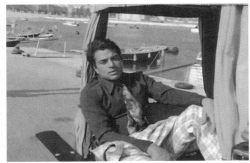

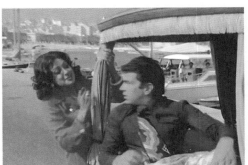 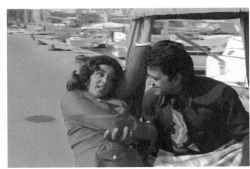

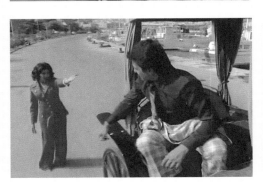 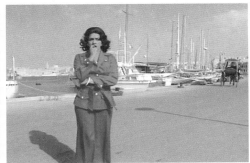

I WAS, ALREADY/ KONT DIĠA' (2009)

LOCATION *Australia Hall, Pembroke*

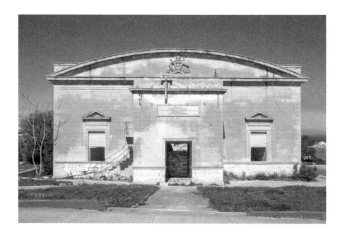

MARK DINGLI'S DIRECTORIAL DEBUT was completely self-funded and its cast predominantly comprised of non-professional actors. The story centres on Karl (Karl Consiglio), an artist who has recently returned home to Malta after a long stint abroad. In many ways this text challenges official representations of the island, and also others included in this volume, insofar as it is an extremely intimate portrayal of twenty-first-century Malta. There are no lavish sets. Rather, domestic, everyday spaces are favoured, extending beyond the tourist imagination. Through Karl, the audience is treated to the rituals of the summer: perpetual socializing in the sweltering heat. However, this particular scene is a playful rupture, a stylized escape from Mediterranean life. Anna (Annabelle Galea) drives to Pembroke, a town on the northern coast of the island that served as a military base during British reign. The skeletal remains of Australia Hall fill the frame. The image plays out to a frenetic jazz score, as Anna performs to an absent audience. Built in 1915 by the Australian Branch of the British Red Cross Society, the building served as both a theatre and cinema. In 1998 the building was gutted by a fire and has remained derelict ever since. Australia Hall was a glorious example of British military architecture. *Kont Diġa'* was released five years after Malta joined the European Union, and although the film focuses on a specific national point-of-view, the overall theme of displacement and ideological conflict, as experienced by Karl, is universal, especially at a time of increased transnational migration. Imbued with a sense of realism, this film has the capacity to simultaneously render one homesick and claustrophobic. ➡ *Charlie Cauchi*

Photo © Mark Cassar

Directed by Mark Dingli
Scene description: Anna performs to an imaginary audience
Timecode for scene: 0:23:11 – 0:25:28

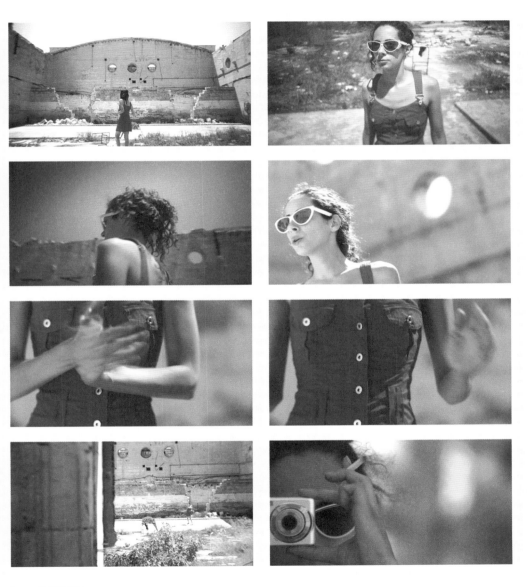

EARLY VISIONS

Text by
GIOVANNI
BONELLO

The Presence of Film-makers in Early 20th Century Malta

DOCUMENTATION ABOUT early film-making in Malta appears rather scant, as are research articles by scholars, even though Malta had joined the cinema craze quite early on. Barely one year after the first public viewing in Paris, motion pictures were regularly screened at a public hall in Valletta early in January 1897.

One established Maltese professional photographer, Salvatore Lorenzo Cassar, can today claim to have been the very first Maltese to experiment with the new medium. A 1915 publication records Cassar's pioneering cinema efforts: 'He is the only one in Malta who photographs for the cinematograph' (Macmillan p.377). But Cassar's film-making activities had in all probability started as early as 1909. In 1910, a daily local publication reported that a film of that year's Imnarja Agricultural Exhibition by S. L. Cassar [1] had been shown at the Cinema Teatro Internazionale in Valletta. It had been revered for its excellent quality and was seen to be more superior, the newspaper added, to the previous year's Imnarja film, which was also produced by Cassar (*Daily Herald*, 13 July 1910).

By 1910, local cinemas were actively screening Cassar's productions. One of his major feats was a 2,000-foot-long feature of the ceremonies held in Malta to mark the death of King Edward VII. This film, shown in cinemas in Valletta and Sliema, received high critical acclaim, with the *Daily Malta Chronicle* (1 June 1910) reporting that it 'was greatly admired for its clearness and its accuracy of detail […] Mr S. L. Cassar's enterprise was highly commended'. Regrettably, none of the work of this pioneer of cinematography in Malta seems to have survived.

The next certain presence of film-makers in Malta coincides with the International Eucharistic Congress, held in Malta in 1913. Professional foreign film-makers saw the Congress as a newsworthy opportunity. Still photos show one

(or two?) foreign movie-makers filming the Congress events with their large professional cine-cameras. The Congress reels have similarly disappeared. No record of cinema-making activity during World War I has been traced so far either, though it undoubtedly existed. However, the next significant step in film-making in Malta should have occurred in 1920.

A reputable Hollywood enterprise, C. L. Chester – Chester Comedies; Chester Travels – proposed to shoot a travelogue about the Maltese islands. Chester's firm had produced a huge number of comedies – well over 160 are listed, and its owner described himself as 'the man who originated the idea of a series of travel films' (Giovanni Bonello, 'The Earliest Film-makers in Malta', p.45). He took his initiative seriously, intending to produce one travelogue a week, starting from November 1916. Malta was to be included in this enterprise. Chester employed leading cameramen for the job: Victor Miller from Pathé; W. O. Runcie from Gaumont; and Raymond Angel from Paris Éclair. When London received Chester's request to film the Malta travelogue, files were opened and committees set up to investigate and report. The National Archives of Malta house these files. The worst kind of bureaucracy kicked in. After many exchanges between London and the authorities in Malta it was decided to grant Chester's application, but to appoint a joint civil, naval and military committee to consider a suitable programme and itinerary, which also had to be approved by the Governor of Malta, saving vetoes for military security concerns.

By now Chester had grown thoroughly sick of all the dilly-dallying – well over seven months had been wasted. Material held in the National Archives of Malta shows that at the end of June he wrote (understating quite politely just how disenchanted he was with the

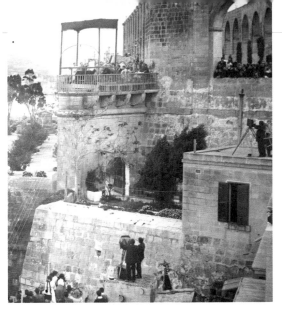

equipment he made himself'. His public debut was his documentary *Carnival in Malta 1928* (1928), shown locally to packed houses, and in New York to the Maltese community. One local daily reported that it 'attracted such large audiences that even the gangways of the cinema were crowded'. It added, inaccurately, that 'it is the first to be made in Malta by a Maltese producer' (*Daily Malta Chronicle*, 9 June 1928).

A Maltese periodical published a review of Vella Gera's film, shown at the Cinema Internazionale: 'In it we observed clear lighting, good humoured captions and a perfect coordination' (*The Times*, 17 February 1979). Patronizingly it added it would have been impossible to distinguish it from films shot overseas. Filmed in black and white in February 1928 with a 35mm hand-cranked cine-camera, which Vella Gera had bought for £12, the silent film was shown in June at the Cinema Commercio Internazionale and at the Cinema Commercio. The film features all the highlights of that carnival. It ran to 1,400 feet, divided in spools of 100 feet each which, in turn, had to be split in three parts to fit the limited capacity of Mr Vella Gera's development tanks (*The Times*, 17 February 1979). This production's popular success prompted Vella Gera to repeat the experience the following year. The result was *Eventful Malta 1929*. A pamphlet described the film as 'the supercolossal of the local production' (*The Times*, 17 February 1979). When shown again 'by general request' at the same cinema on 26 June 1929, the programme included three new features. Patrons paid 7 pence for the entrance ticket, or 3 shillings for a box. What featured in *Eventful Malta* seems to have changed with each public viewing (*The Times*, 17 February 1979).

By 1931 a number of enthusiasts, calling themselves the Malta Leading Movies Association, had organized themselves to disseminate their love of films through an illustrated, multilingual fortnightly magazine *Malta Kinema*. The Association meant to produce a full-feature, entirely Maltese film. The movie, *Holma ta' Gloria/A Dream of Glory* had its script published in the magazine by instalments (*Malta Kinema*, 4 November 1931 and 12 December 1931). To my knowledge, this first Maltese production never materialized. ✤

NOTES

1. *Imnarja* is a national feast celebrating St Peter and St Paul.

whole matter) advancing the lame excuse that he now had no cameramen available for the work in Malta, and hinting vaguely he might reconsider the following year. At this stage the project was defunct and a fine opportunity for a first professional film about Malta ended rather sadly, buried under heaps of colonial bureaucracy.

The following year, cine-cameras were again present in Malta. On the occasion of the official visit of the Prince of Wales (later the short-lived King Edward VIII) in 1921, two cine-cameras can be seen in a photograph, filming the Prince on the parvis of St John's Co-Cathedral, accredited paparazzi in the wake of that royal visit.

This introduces the other important pioneer of film-making Alfred Vella Gera (1901–1989). He shot his first feature film in 1928. A banker by profession, Vella Gera took his hobbies, photography and film-making, very seriously. His output of still photographs is well known, but here I wish to remember his sterling contribution to cinematography: 'He was completely self-taught, had his own laboratory at home, produced the films himself and converted part of the house into a cinema […] much of the

Barely one year after the first public viewing in Paris, motion pictures were regularly screened at a public hall in Valletta early in January 1897.

maps are only to be taken as approximates

MELLIEHA

RABAT

MA

MALTA LOCATIONS
SOUTH EAST

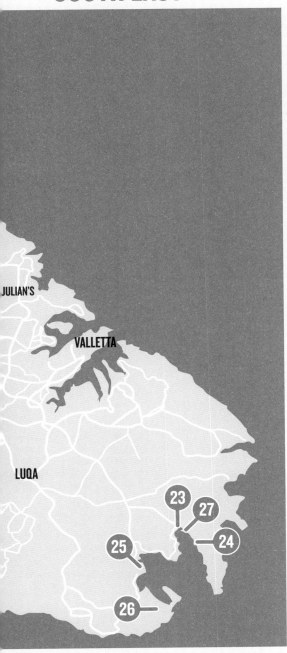

JULIAN'S

VALLETTA

LUQA

VENDETTA FOR THE SAINT (1969)

Madonna of Pompeii Square, Marsaxlokk

WITH A PLOT pitting the famed Simon Templar against the Mafia on their own turf in Sicily, producer Lord Lew Grade was reluctant to actually shoot *Vendetta for the Saint* on Sicilian soil for fear of retaliation from the crime syndicate. As claimed by Roger Moore in a *Times of Malta* interview (December 18th, 1967), he was the one to originally suggest that Maltese locations could easily stand in for the Sicilian landscape, after he had seen scenes of Malta on the BBC. Indeed, viewers will be fascinated as the story, set in Sicily, takes Templar on a trawl across Maltese locations including Addolorata Cemetery, Binġemma, Birżebbuġa, Burmarrad, Ghadira, Madliena Valley, Marsaxlokk, Mellieħa, Naxxar Square, St Paul's Bay, Valletta and Verdala Palace. Having narrowly escaped from the Mafia's stronghold in a cliff-top castle, Simon Templar reaches an idyllic Sicilian seaside village. The only cues that this could truly be a Sicilian village are the dialogue – Italian is dubbed onto the Maltese women washing their laundry in the public washhouse – and the Palermo sign on the bus that slowly rambles into the village square. Devoid of these hints, the scene invokes a glimpse of the long-lost tranquil fishing-village lifestyle that Marsaxlokk once enjoyed. Even though the Church dedicated to the Madonna of Pompeii still dominates Marsaxlokk's seaside square, the scene today is of a bustling market village, enticing tourists and locals to buy fresh fish and souvenirs. **⇢Jean Pierre Borg**

Photo © Stefan Stafrace

Directed by Jim O'Connolly
Scene description: Simon Templar is being hunted down by the Mafia
Timecode for scene: 1:09:44 – 1:12:22

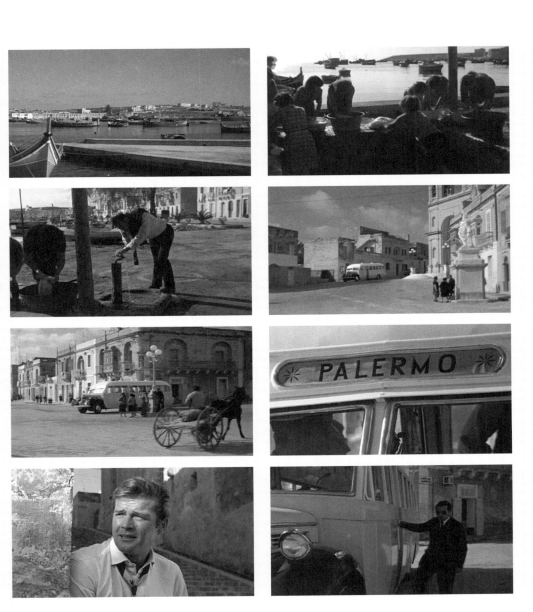

THE MACKINTOSH MAN (1973)

LOCATION ⟩ *Marsaxlokk*

BASED ON THE SPY THRILLER *The Freedom Trap* (1971), written by Desmond Bagley, *The Mackintosh Man* was filmed at a time when Malta went through a period of mass tourism development. Its national airline Air Malta was launched in 1973 and the island saw a boom in low-budget tourism from the United Kingdom. Hollywood was also going through a period of transition, with the increase in runaway productions, favouring exotic locales over LA-based studios. If we consider the distinct shift in cultural production for both sites, it is easy to read *The Mackintosh Man* as an archetypal example of espionage films made in the era. Directed by John Huston, the film makes use of a number of international settings and a stellar cast of stars from both Hollywood and European cinema that included Paul Newman, James Mason and Stefania Sandrelli. Paul Newman's Rearden, an undercover British intelligence officer, is on the run after escaping from prison in the United Kingdom. Somehow or other he ends up in Malta with the beautiful Mrs Smith (Sandrelli). Although most of the action takes place in Valletta, Marsaxlokk is the first vista seen. The Cold War momentarily thaws thanks to this picture-postcard perfection: Rearden and Smith take a leisurely swim at their villa, behind them the unspoilt harbour of this quaint fishing village.
⊷ Charlie Cauchi

Photo © Jean Pierre Borg

Directed by John Huston
Scene description: Rearden and Mrs Smith hide out in the tranquil village of Marsaxlokk
Timecode for scene: 1:12:44 – 1:14:14

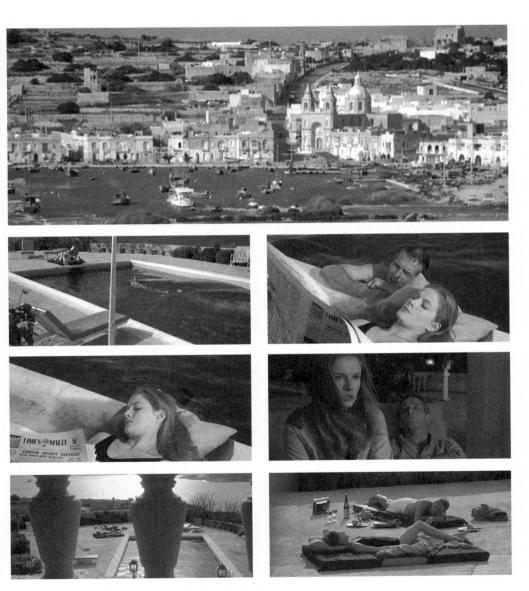

WHEN PIGS HAVE WINGS/ LE COCHON DE GAZA (2011)

LOCATION *Tanks Street, Birżebbuġa*

IN THE CURRENT POLITICAL CLIMATE, it is somewhat difficult to find a common enemy for both Israelis and Palestinians. Entertaining and thought-provoking, *Le Cochon de Gaza* is a powerful attempt at pointing out common ground in this seemingly never-ending conflict. Jafar (Sasson Gabai) is a humble Palestinian fisherman, who, of all things, fishes out a pig from the Mediterranean. He tries unsuccessfully to sell the pig first to a UN official and then to Ylenia (Myriam Tekaïa), a pig-breeder at a Jewish settlement who rather than the pig, needs its semen. *Le Cochon de Gaza* tackles the ongoing conflict from a satirical and atypical perspective. Sylvain Estibal manages to reproduce the ambience prevailing in Gaza with realistic fidelity, a feat all the more remarkable as the film was, for obvious reasons, not shot in the featured location. Malta stands in perfectly for Gaza, with a derelict hotel instead of a bombed building, a high boundary wall, instead of the Gaza separation barrier, and the boathouses turned simple-summer-holiday-homes of St Thomas Bay as a Palestinian settlement. In this scene, shot in the village of Birżebbuġa, Jafar enlists a very young boy to buy him Viagra – an important ingredient in his quest to gain commercial gain from the pig. *Le Cochon de Gaza* has earned a steady fanbase who cherish the fact that, nothwithstanding its light-hearted approach, this fictitous drama does not shy away from exposing the tragic consequences of hostility between both sides.
➻ Jean Pierre Borg

Photo © Jean Pierre Borg

Directed by Sylvain Estibal
Scene description: *Jafar enlists a young boy to go for an errand*
Timecode for scene: *0:37:01 – 0:38:00*

CAPTAIN PHILLIPS (2013)

Malta Freeport, Kalafrana

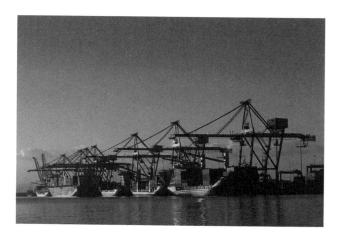

PAUL GREENGRASS PRESENTS a hyper-realistic account of a real-life incident involving Captain Richard Phillips (Tom Hanks) and the hijacking of an American-registered ship, the MV *Maersk Alabama*. The bulk of *Captain Phillips* was shot at the water tanks in Rinella , and off the coast of Malta, with the Mediterranean seascape doubling as that of the Indian Ocean; however, the selected sequence takes place at the Malta Freeport. Located in the southern region of Malta, the Freeport presents a striking contrast to other Maltese cinematic settings, insofar as it shifts focus away from Malta's natural beauty and heritage, eschewing the myths, traditions and connotations placed on the national landscape. Instead, the scene favours the industrial, highlighting the daily workings of this harbour setting. Playing the part of the Salalah Port in Oman, scores of containers mark the building blocks of global economics and international trade, a clear contrast to the barren Somali landscape of the previous scene. Alternating between aerial shots and the hypermobile close-ups that have become synonymous with Greengrass's work, this scene captures the procedural elements of marine life, with Captain Phillips introducing the audience to the vessel that will eventually become the space where the narrative's main drama unfolds. ➥*Charlie Cauchi*

Photo © viewingmalta.com

Directed by Paul Greengrass
Scene description: *Captain Richard Phillips arrives at the Salalah Port in Oman*
Timecode for scene: *0:09:14 – 0:10:14*

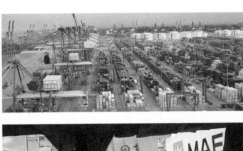

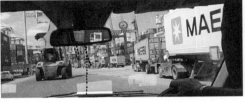

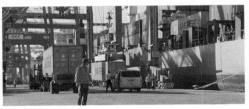

SIMSHAR (2012)

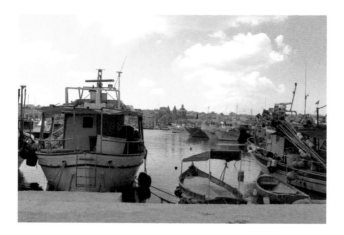

THE TITULAR SIMSHAR is not only the name of the boat at the centre of one of the worst tragedies in Maltese history, which claimed the life of three fishermen and an 11-year-old boy; it is also an example of a Maltese tradition, where a house or other property is named by amalgamating the proprietors' forenames – in this case Simon and Sharin. Although the fishing village of Marsaxlokk has featured in several films, this is a rare instance in which it is not being disguised and passed on for another location. The bold colours and superstitious eyes of the traditional Maltese *Luzzu* boats proudly display the vibrant nature of this village. In this particular scene the fishermen are heading out to search for the missing *Simshar*. The angles chosen are reminiscent of those used in the scene during which the *Simshar* departed for the doomed voyage; however, this time its berthing space is ominously empty and the sea is an almost unnatural cyan colour (a serendipitous occurrence arising from the strong currents in the area the day before filming that unearthed the sandy seabed). The village church is seen in the background, reminding the audience of young Theo (Adrian Farrugia) and his mischievous antics in the church square during the film's opening sequence.
➻ Rebecca Cremona

Photo © Jean Pierre Borg

Directed by Rebecca Cremona
Scene description: Fishermen embark on a search expedition for the missing Simshar
Timecode for scene: 1:21:27 – 1:23:12

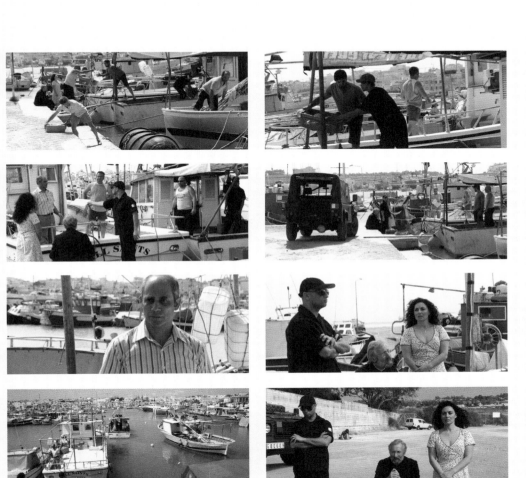

CINEMAS IN THE SOCIAL URBAN LANDSCAPE

Text by
MARC
ZIMMERMANN

'**LOCATION, LOCATION, LOCATION.**' The 'where' and 'when' have always played key roles, not only in the making of films, but also – prominently – in their exhibition on the big screen.

Cinemas have been a fixture in Malta's and Gozo's built and social landscape for over a century. From around 1905, silent picture houses mushroomed in Valletta and Sliema during the country's first cinematic boom. Both towns would develop into the islands' leading cinema cities that – following the introduction of the talkies in the late 1920s – would boast increasing numbers of flagship venues, particularly during cinema's Golden Age.

Despite the nation's petite size, nearly two hundred screening venues drew in generations of audiences across twelve decades. These screens ranged widely in size and design, from grand movie palaces to small picture houses, from fleapits to dedicated Armed Forces' screens, from band club auditoria to village parish halls.

To ensure patrons would queue eagerly, a cinema had to meet two important criteria: it had to be located in an audience 'hotspot', and it

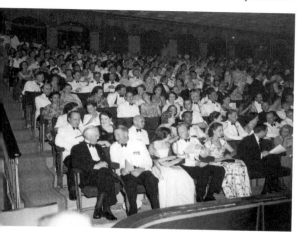

had to beat the competition by showing top titles first. Following Malta's very first screening of moving pictures in 1897, Valletta soon developed into its first and foremost cinema city. Small picture houses, converted from pre-existing premises, blossomed along the capital's main artery, today's Republic Street. Among the first dedicated screens opening in the early twentieth century were Cinema Salinos (today's Café Cordina), Harding's Cinematograph (St George's Square) and the Teatro Internazionale (inside the Knights' Auberge d'Auvergne, bombed during World War II).

Sliema, a short ferry ride from the capital, which had been thriving as a fashionable seaside town since the late 1800s, now attracted the film exhibition industry. Strikingly named cinemas such as the Grand Cinematograph Melita, the Conqueror, the Duke of Edinburgh and Sans Pareil (Unmatched, Fr.) clustered around the Strand, screening silent films and international newsreels (Giovanni Bonello, 'Cinemas in Malta Before World War I').

Further focal points developed in the Three Cities (foremost the Rialto in Cospicua) and in Ħamrun, including the vast Hollywood and the grandly-named Radio City Opera House. Cinemas of all types and sizes continued to spread across Malta and Gozo during the first half of the 1900s. Apart from the strictly commercial 'picture theatres', a plethora of others, including religious and military venues, ensured that everyone could be reached, right in their neighbourhood.

The draw of films was so strong that even respectable stage theatres embraced popular entertainment for commercial reasons. In 1927 the striking Manoel Theatre was adapted to a full-time cinema (Paul Xuereb, *The Manoel Theatre: A Short History*). According to material held at the National Archives of Malta (NAM CSG02 11 1931), the grand Royal Opera House was the first to screen

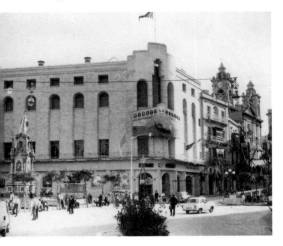

talkies. The Art Nouveau Orpheum Theatre in Gżira also became a cinema in the 1950s.

In the mid-1930s, sound and colossal productions heralded a Golden Age. Larger, strikingly decorated cinemas increased audience appeal and capacity, often above 1,000 seats. In Valletta, the Capitol and Coliseum led the way. In Sliema the Gaiety, Carlton and Majestic (its attractive facade survives on St Anne Square) drew crowds daily, matched by screens in Paola (Empire and Regal), Ħamrun (Rex and Trianon), Birkirkara (Roxy) and Gozo's capital Victoria (Leo and Royal).

World War II also scarred the local cinemascape. Valletta's Regal and Opera House; Sliema's Gaiety; and Cospicua's Rialto were destroyed or substantially damaged during the incessant bombing raids of 1941/42. And yet, many patrons remained undeterred, seeking big-screen escapism. When screenings were interrupted by air-raid sirens, audiences had to scramble into the nearest underground shelters, re-emerging after the 'all clear' to return to the cinema for the rest of their interrupted film.

As European cinemas struggled to attract their pre-war audiences, Malta enjoyed a resurgence when large new cinemas opened throughout the 1950s. In Valletta the striking and vast Embassy with its two tiers of balconies, and the two-screen Savoy (seating a combined 2,300 patrons) provided new diversions. Further venues were built in Sliema (Alhambra and Plaza), Qormi (Amazon), Zabbar (Buckingham), Floriana (Comet), Cospicua (a new Rialto, now heritage-protected thanks to the Cinema Heritage Group), and across the country.

The 1950s also brought a significant change in the way films were distributed. Previously, individual entrepreneurs had imported movies through a range of ad hoc agreements. Thus the selection of films at their cinemas would often differ from nearby competitors. In the 1950s a sole local distributor emerged, establishing a country-wide schedule of releases through staggered distribution.

Films would typically be imported to Malta as a single copy only, several individual 35mm reels making up one full film. Prints were comparatively expensive: it made economic sense to circulate each one among numerous local cinemas. A hierarchy was established, ranking first-, second-, third- and fourth-run venues.

As the cinematic epicentre of the islands, Valletta would screen new releases first. In particular, its two flagship cinemas, the Embassy and the Savoy, would battle it out for first pick. Once other capital city venues had screened a film, it would move to the second-run tier of cinemas in Sliema. Here the film would start at the Alhambra or Plaza, followed by the other local cinemas, before starting to zigzag across the island, beginning at the Hollywood (Ħamrun), the Rialto (Cospicua) and the Adelphi (Rabat) (interview with Christopher Spiteri, 2015).

One anecdote (interview with Martin Vella Pace, 2015) tells of two cinemas that would show the same copy of a film by staggering the start times by 45 minutes. The reels had to be driven from Valletta's Savoy to Gżira's Orpheum in two batches, during the Savoy's intermission and again once its screening had ended. The high-stakes relay worked well until the car broke down and the Orpheum's show was interrupted and cancelled, so the exhausting and costly practice was abandoned.

The days of the grand, single-screen movie palace and of transporting boxes of heavy reels across the country for numerous months may be long gone, but they are certainly not to be forgotten. ✢

As the cinematic epicentre of the islands, Valletta would screen new releases first. In particular, its two flagship cinemas, the Embassy and the Savoy, would battle it out for first pick.

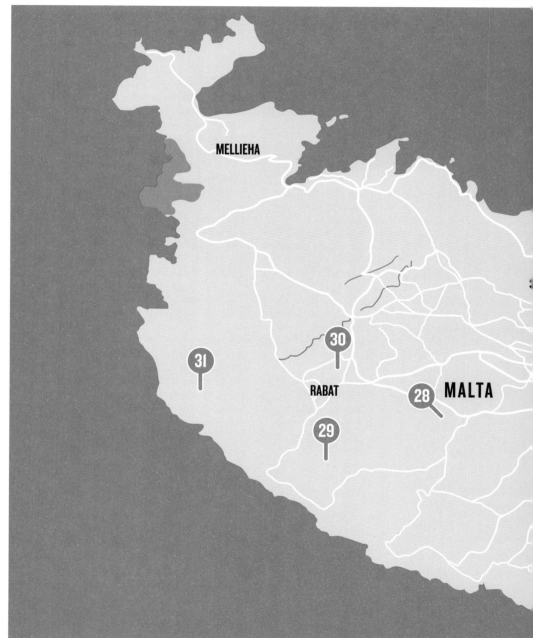

N

MALTA

maps are only to be taken as approximates

MELLIEHA

30

31

RABAT

28 MALTA

29

MALTA LOCATIONS
WEST

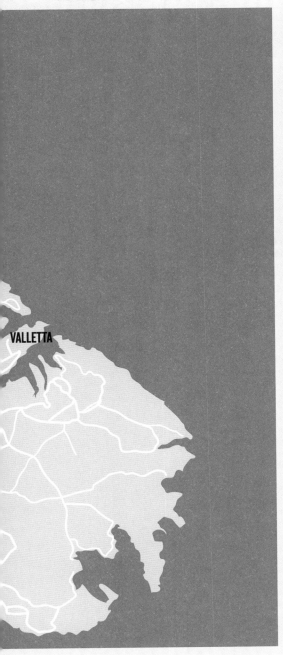

VALLETTA

BOLIBAR (1928)

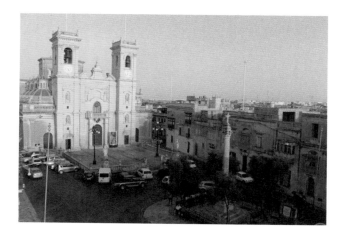

SET IN 1812 during Napoleon's Peninsular Campaign, the Spanish town of Bolibar has been occupied by Hessian troops serving under Napoleon. Driven out of his own home by the invaders, the Marquis of Bolibar devises a cunning plan to retake the town; but fate has it that he is caught and executed by a firing squad before he can enact his plan and give the three prearranged signals to the army of irregular Spanish troops outside the city walls. In spite of his death, as if through a curse, the three signals are inadvertently given out by the four Hessian officers responsible for the Marquis's demise. As insurrection brews inside the town's main square, the Spanish troops lay siege to the town in one final showdown. When the whole central area of Ħaż-Żebbuġ was taken over for this unprecedented filming activity, scores of curious people wishing to glimpse the action prompted the authorities to transfer police officers stationed in the nearby village of Siġġiewi to Ħaż-Żebbuġ for the duration of filming. No fewer than 900 costumes similar to those worn in 1810 had to be specially made and brought to Malta, where much of the exterior filming was carried out. Apart from the Devonshire Regiment and the Royal Artillery, 1,000 Maltese are said to have also taken part as extras, possibly as the insurgents. **➻Jean Pierre Borg**

Photo © Jean Pierre Borg

Directed by Walter Summers
Scene description: The people of Bolibar take it to the streets
Timecode for scene: 1:37:30 – 1:48:30

TRENCHCOAT (1983)

LOCATION *Verdala Palace, Buskett*

MARGOT KIDDER (Mickey Raymond) stars in this shabby Disney comedy caper. If we shift our attention away from the film's shortcomings, *Trenchcoat* proves successful at showcasing Malta's natural and architectural heritage. In true literary style, Mickey has escaped to Europe to make a start on her novel. While in Malta, her pulp fiction transposes off the pages when she unwittingly becomes involved in a plot to smuggle plutonium. But before her holiday is transformed, she arrives on the island and is whisked to her hotel, fictitiously named The Falconry. In reality, this building is of great national significance. Its true identity is Verdala Palace. Built in the late sixteenth century in one of the island's few woodland areas by Maltese architect Gerolamo Cassar, it originally functioned as a hunting lodge and since the 1980s has served as the president's summer residence. *Game of Thrones* (HBO, 2011–) fans may also know it as Illyrio Mopatis House. The building itself is an archetype of Renaissance architecture: a simple rectangular structure houses an interior of vaulted ceilings, columns and marble staircases. Within the confines of the narrative, Malta conveys a heritage-chic quality. It evades the full impact of tourism-development by avoiding areas like Qawra or Mellieha, which had become inexpensive package-holiday destinations at the time, accentuating the island's cultural appeal. This cinematic vision produces an extremely European depiction of the island, one more akin to Greece or Italy. Furthermore, it is interesting to note the absence of Maltese actors in leading roles and the somewhat patronising view of the locals. *Trenchcoat* can also be read within a larger framework of Maltese foreign policy. At the time, Malta's relationship with the United States was somewhat strained, particularly because of the country's ties to the Arab world and this is played out in the narrative. **↦Charlie Cauchi**

Photo © viewingmalta.com

Directed by Michael Tuchner
Scene description: On her arrival, Mickey takes a taxi to her hotel
Timecode for scene: 0:05:20 – 0:07:57

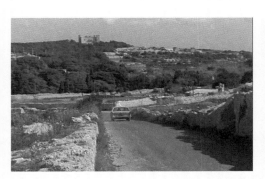 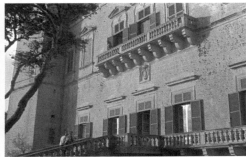

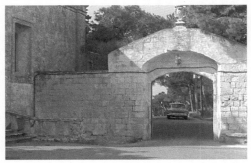

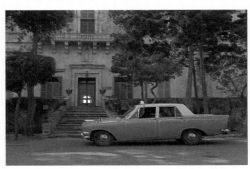 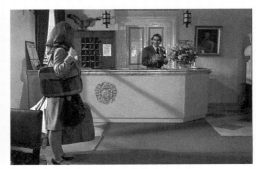

PIRATES (1986)

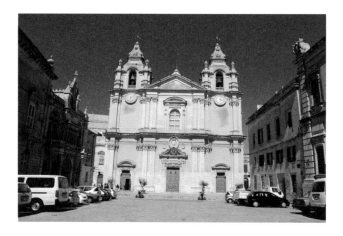

WHEN *PIRATES* PREMIERED out of competition at the 49th Cannes Film Festival in 1986, the larger-than-full-scale replica galleon built for the film was taken to Cannes for all to admire. Originally budgeted at $15 million, the exotic filming locations, special effects and the galleon, which was called the *Neptune* and reputedly cost $8 million alone, skyrocketed the budget to $40 million. Roman Polanski had spent a decade planning *Pirates*, navigating his way through myriad delays. When he finally managed to put it back together, *Pirates* became one of the all-time duds, earning a mere $2 million in the United States and being lambasted by the critics. The baroque St Paul's Square in Mdina and its environs are here standing in for the town of Maracaibo. Captain Thomas Bartholomew Red (Walter Matthau) and his first mate, Frog (Chris Campion) have just managed to infiltrate the town in disguise and take hold of the golden throne they were after. Their accomplice Boomako (Olu Jacobs) however, realizes their scheme is not going as planned and, disguised as a buxom dame, traverses the narrow streets and main square of Maracaibo. Surrounded by seventeenth- and eighteenth-century palaces and St Paul's Cathedral, the square is here witness to a grim scene. Twelve mutinous crew members, who have been hanged, are left on display in the middle of the square, in a scene reminiscent of the Spanish Inquisition.
⟿ Jean Pierre Borg

Directed by Roman Polanski
Scene description: Boomako makes his way through Maracaibo
Timecode for scene: 1:32:47 – 1:33:17

LARGO WINCH (2008)

Chapel of the Nativity of the Virgin Mary, Mtahleb

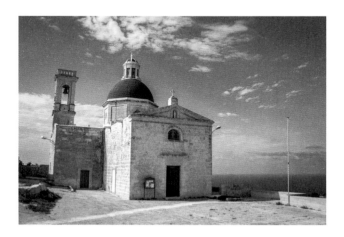

LARGO WINCH is a 2008 French film based on the eponymous Belgian comic book series by Philippe Francq and Jean Van Hamme. The film, written and directed by Jérôme Salle and starring Tomer Sisley as Largo Winch, was loosely based on the first four issues of the series. In the film, Nerio Winch (Miki Manojlovic), owner and majority shareholder of the W Group, is murdered in Hong Kong. Nerio's death sets off the search for his heir, a child that had been adopted from a Yugoslavian orphanage 28 years earlier. Through a series of flashbacks, the audience discovers that Largo was raised by a French-Croatian family. But that all changes when Nerio takes him in, raising him to take over his company when the time is right. The filming facilities at Rinella were what initially attracted the producers to the island. However, they soon realized Malta could offer much more. The Yugoslavian orphanage and police station, which is located in the Balkans, were actually both Maltese locations, as were the Swiss boarding school and the airport. The chapel dedicated to the Nativity of the Virgin Mary in Mtahleb provided the rural Balkan setting where the funeral of Largo's adoptive father takes place. The skyline is dominated by this chapel that lies on top of a quaint troglodyte hamlet, tucked away on the cliff sides shielded by the boulder scree.
↝ Jean Pierre Borg

Directed by Jérôme Salle
Scene description: *Largo returns to Croatia for his adoptive father's funeral*
Timecode for scene: *0:42:21 – 0:42:41*

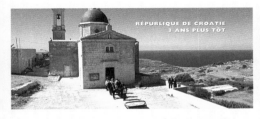

 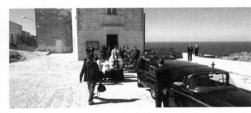

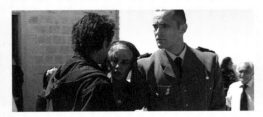 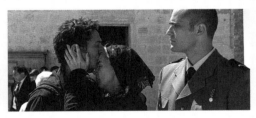

Images © 2008 Pan-Européenne Production, Wild Bunch

THE LAZARUS HARBOUR

Text by
KENNETH
SCICLUNA

THE DARK IS DISPELLED by the incessant ringing of a teaspoon at 5 a.m.

The blue air pricks the bare shins of a boy in shorts and a Ladybird book in hand, as he follows his father through a gauntlet of trees, amid falling shards of birdsong.

The boy sits on a stool, in the thick hum that becomes a rumble that becomes a roar. Salt and diesel, rust and old wood. The sun hits the tops of yellow cranes that grate along furrows, as boiler suits scoot on bikes. Hammering, banging, dropping and clanging. Bursts of fuzz and welder's sparks. A shout, a horn, a boat pulls up alongside.

And a fatherly hand. Love offered better protection those days, than boundaries, rules and helmets. From shore to dredger. From the relentless snarl of the engine room, to the mahogany of the master's cabin, and the brass of the wheelhouse.

The claw drops, rummages about, and brings up a tonne of silt pissing seawater in all directions.

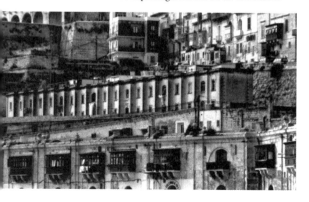

The breakwater. An arm, loving, that slows escape. But the dredger crawls past and opens its hopper, and the harbour's bowels are dropped just beyond.

Living in awe of the master, of the one who works the telegraph. Of the inkpots he lifts. Of the uniform he once wore. Of the bo's'n and the craneman. And of the kind Mr Lee and his chopsticks and his tales of the land of no religion.

A landlubber in the end, the boy lets drop the anchor that a resolutely maritime family had held aweigh for generations.

The Grand Harbour proved not a place of exit but a locus of introspection. An inversion of the order that placed the islands within a liquefied continent, a harbour that was an intricately involuted inland sea that kept surges of exploration within, as much as fearsome waves of frightening possibilities without.

The many inlets, first discovered with the father, swarmed with vessels that made way for the ones that came from abroad. And when the big tankers and liners and destroyers left, those boats were buoyed back inland by their jailers' wake.

A proxy battlefield, where colonizers fought would-be colonizers, the harbour waters frothed over the centuries with blasted limestone and the blood of many, sucking in the echoes of the stories lived by the surrounding townsfolk, and which are still whispered by the dark ripples to those who care to listen.

Outside the window, in the distance, I can see the lights atop an oil rig tower. The belly roar of eight docks has long been attenuated. The perennial

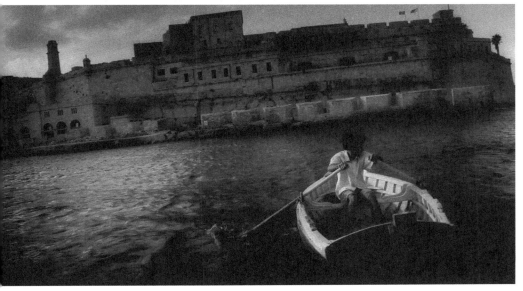

Above © David Pisani, Neville Attard
Opposite © Kenneth Scicluna

departures, of the forlorn battleships, at night, in *Malta Story* (Brian Desmond Hurst, 1953), on a sea frightening in its black quietude, of the warships in choppy seas in 1979, to the gentrification of the shoreline and the inlets, have caged the hoarse shouts from one balcony to another, the occasional hawker's horn and the pealing of many a bell, and turned them, like the stubborn regatta rowers, into a capsule of pickled hardiness.

For a coast known for its steadfast bastions, the harbour has been moulded to fit the faces of other places: *Cutthroat Island* (Renny Harlin, 1995), *U-571* (Jonathan Mostow, 2000), *The Count of Monte Cristo* (Kevin Reynolds, 2002), *Alexander* (Oliver Stone, 2004), *Munich* (Steven Spielberg, 2005) and *World War Z* (Marc Forster, 2013), have found it malleable enough to stand in for many a different country. The local effort, however, has yet to unravel its facts, mysteries and possibilities.

As with the watery surface that ebbs and flows, the harbour folk have shifted to and fro. From a cosmopolitan confluence of many nations and beliefs, chased away by Axis bombs, brought back by cheap tenancy, drawn away by air and sun, lured back by fashion, the hope is that a local weaver of tales will dip her feet, will wet his hands and say what has not been told.

From a net receiver of cultural influence, like the rest of the nation, the Grand Harbour needs to be an antenna, sending out stories and experiences. The breakwater needs to be surmounted. The forts no longer hoarders of voices. The jetties points of departures of hopes, dreams and nightmares. The steep steps and rank alleyways veins and arteries channelling testimonies that reach back thousands of years.

Whether insular or continental in outlook, few locals have sought interest in the space which, by its seeming emptiness perennially sucking in what is without, has defined the small, but dense, mass of land around it. Each inlet a veiled woman, each cave a mouth denied, each rock ready to calf and smash its way down to the dark green meadow. The roar needs to rise again. It needs to carry across the middle sea and harness the *Grigal* (North East), the *Majjistral* (North West), and find the eyes and ears of those who have looked and listened elsewhere. The ringing has to start again in earnest from the earliest of hours. The windows of the flats light up, open up, sound music during the day, pour out sighs at night. The balconies need to shout out louder, the boatsmen bare their teeth, the children taste the salt. Like a shark instance, snatching the story before it is cast in concrete.

Each to each, we need to sing. ✚

The Grand Harbour proved not a place of exit but a locus of introspection.

MALTA LOCATIONS
NORTH

VALLETTA

SONS OF THE SEA (1926)

LOCATION *Il-Minżel tal-Majjiesa, Għajn Tuffieħa*

FORMING PART OF THE SPRAWLING Majjistral Nature Park, Il-Minżel tal-Majjiesa is a gem of untouched Maltese foreshore accessible only through a narrow dirt road barely wide enough for a car to pass through. Access to this area was for many years prohibited due to the Għajn Tuffieħa British Barracks, which occupied the overlying plateau. *Sons of the Sea* is not only considered the earliest feature film to be partly filmed in Malta, but research has also placed this film as the first ever fiction film to boast Admiralty support. It was certainly this unprecedented support from the Admiralty that granted producer/director Harry Bruce Woolfe and his film crew access not only to film on the HMS *Malaya* and other ships based in Malta, but also exclusive access to this location. Set against the backdrop of the Great War, the film follows the careers of two young men, Derek who enrols as a Navy officer and Bill who trains to become a seaman. When Derek is sent to fight in the Battle of Jutland, his fiancée Diana enlists as a nurse and is sent to Malta. Shortly after the Armistice the lovers are reunited thanks to a chance encounter in the Mediterranean. The joy is however short lived. While exploring a nearby island, Diana is kidnapped by a band of bandits who demand a ransom. Led by Derek, the blue-jackets rapidly find the brigands' hideout in a rock-cut apiary and after a suspenseful struggle on the cliff's edge, Diana is rescued. **➻Jean Pierre Borg**

Photos © Jean Pierre Borg

Directed by Harry Bruce Woolfe
Scene description: Saving the damsel in distress
Timecode for scene: 0:42:16 – 1:15:06

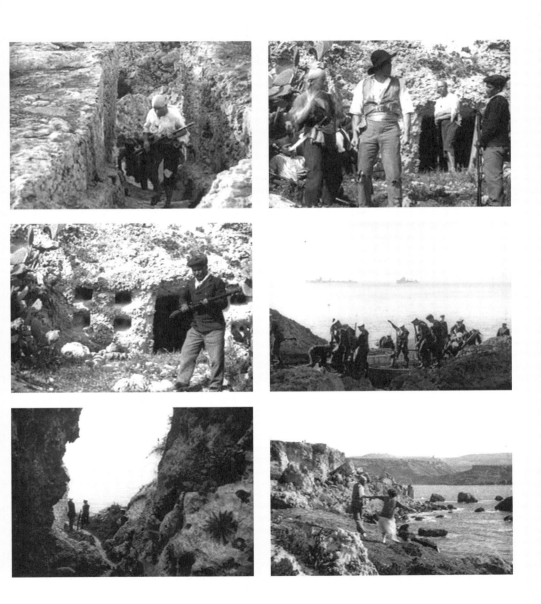

TELL ENGLAND (1931)

LOCATION *Mġiebah Bay, Selmun*

HAILED AT THE TIME AS the 'best War picture yet', *Tell England,* directed
by Geoffrey Barkas (a Gallipoli veteran) and Anthony Asquith (son of World
War I Prime Minister Herbert Asquith) is possibly more of an indictment
of war than anything else. The scene of the ANZACs singing 'Australia will
be there' as they make headway up the gentle slopes of Gaba Tepe, briefly
cheats the viewer into believing that there could possibly be a happy ending
to this dramatic retelling of one of the most bloody World War I engagements.
Having cost the lives of more than 130,000 on both sides, the Battle of
Gallipoli remains one of the darkest chapters in military history. Mġiebah
Bay is off the beaten track and only frequented by a few locals and tourists.
Quaint as it still is, Mġiebah Bay wasn't the reason why, in the spring of
1930, a handful of actors, five camera men and technicians armed with ten
tonnes of explosives moved to Malta to re-create the infamous 1915 Gallipoli
Campaign landings. Another beach had been prepared with trenches, barbed
wire and special effect 'bombs'. Maltese extras were dressed as Turkish
soldiers and the destroyers and picket boats, which had been provided by the
Mediterranean fleet, were manned and in place. Everything was set except
the weather, which made it impossible to film the landing of the troops. The
only alternative became Mġiebah Bay, which was on the other side of the
island and could only be reached by 'a couple of miles of goat-like scrambling
along narrow precipitous paths'. Barely two hours later, beneath a terrible
bombardment of shells and blank ammunition, the scene was filmed.
➻Jean Pierre Borg

Photo © Jean Pierre Borg

Directed by Anthony Asquith and Geoffrey Barkas
Scene description: Australia will be there
Timecode for scene: 0:15:45 – 0:19:31

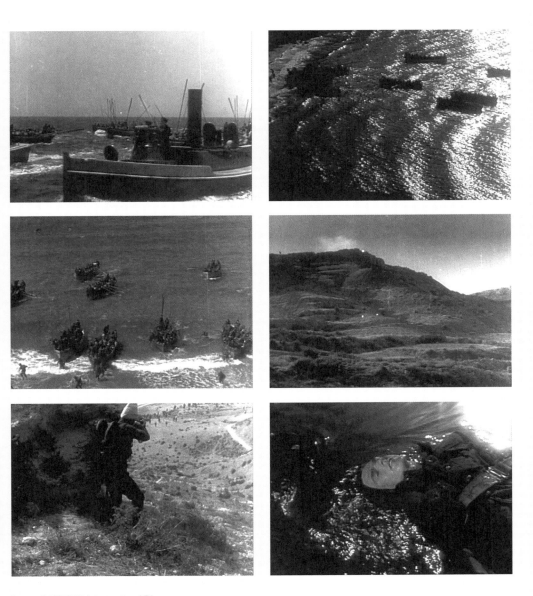

Images © 1931 British Instructional Films

SHOUT AT THE DEVIL (1976)

LOCATION *Church Street, St Paul's Bay*

PRODUCER MICHAEL KLINGER returned to Malta in 1976 to make one of British cinema's biggest independently financed films of the era, this time with director Peter Hunt at the helm. Based on the novel (1968) by Wilbur Smith, *Shout at the Devil* paired Roger Moore and Lee Marvin in the lead roles. This would be Moore's second film based on a story by Smith (*Gold Mine*, 1970), the first being *Gold* in 1974, which was also directed by Hunt and produced by Klinger. According to industry reports, cast and crew were scheduled to spend two weeks on location in Malta. In truth, the production shot on-site for a total of six weeks and employed hundreds of Maltese extras. Filming also took place in Europe and Africa. This opening scene illustrates the scale of the production. British gent Sebastian Oldsmith (Moore) arrives at Zanzibar market in 1931, en route to Australia. Unbeknown to him, Oldsmith is followed by Mohammed (Ian Holm), the mute servant of an Irish American ivory poacher named Colonel Flynn O'Flynn (Marvin). While the water tanks at the Film Studios in Kalkara were used to reconstruct the German battleship *The Blucher*, St Paul's Bay is the site where this encounter occurs. The streets of this once small fishing village are altered, becoming a hubbub of commercial activity. This ambitious picture rejoices in colonial nostalgia, with Holm's representation of Mohammed resulting in a blatant ethnic stereotyping prevalent in many films of the era. ⇢*Charlie Cauchi*

Photos © Jean Pierre Borg

Directed by Peter Hunt
Scene description: Sebastian arrives in Zanzibar. Unbeknownst to him he is being followed
Timecode for scene: 0:03:58 – 0:07:02

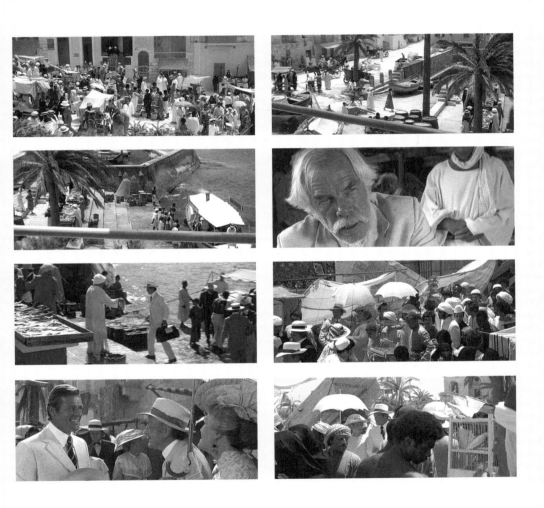

KATARIN (1978)

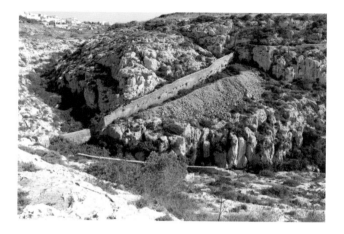

IN MANY RESPECTS, Cecil Satariano was Malta's original indie film-maker, directing a number of short films in the 1970s. In 1977, Satariano made his first featurette. With a running time of 40 minutes, *Katarin* was originally shot on 16mm, but was later enlarged to a 35mm print by EMI, who allegedly purchased the rights to the film. Curiously, it was not released in its native language but was dubbed into English, erasing any linguistic nuances in the process. In my mind, the depiction of the rural setting in *Katarin* bestows a definite nod to the famed watercolours of Maltese artist Edward Caruana Dingli (1876–1950), especially in the manner that the yellow-and-black fabric worn by the women permeates the rocky limestone plains. When the young Katarin (Anna Stafrace) is sexually assaulted, the women of the community take matters into their own hands. In a veiled revolt, the ladies of the valley slowly emerge from the cliff face, hurling rocks at the man who has infiltrated their territory. As they rise up one by one, the women, dressed in the traditional *faldetta* – the national headdress that is now a relic of the not so distant past – cast out this symbol of modernity. �José **Charlie Cauchi**

Photo © Jean Pierre Borg

Directed by Cecil Satariano
Scene description: Katarin is rescued by the villagers
Timecode for scene: 0:30:03 – 0:39:15

POPEYE (1980)

MAVERICK DIRECTOR ROBERT ALTMAN brings E. C. Segar's cartoon strip to life in the big-budget Disney production of *Popeye*. Famously panned by the critics, the film may easily be pulled apart for its flaws but to do so would be short-sighted. Albeit a Disney picture, *Popeye* still sits comfortably within Altman's cannon of work. Nevertheless, rather than focus on Altman, let us shift our attention to the whimsical production design of Wolf Kroger, who is responsible for the creation of the ramshackle costal town Sweethaven. Working with a blank canvas, Kroger built the ambitious set entirely from scratch, with the assistance of 165 local construction workers. Built to painstaking detail, it took over seven months to construct and allegedly cost almost $2 million. Sweethaven is the ultimate fantasy environment, accommodating approximately forty houses, a cafe and even its own fire station, church and floating casino. Confined to the secluded Anchor Bay, reality and cartoon-strip seamlessly coexist. Malta is erased, with Kroeger's design effectively fashioning a civilization all of its own. The isolated town of the comic world seems to have been mirrored by the production team: a production complex was built to accommodate the film, encompassing a plaster shop, carpenter's studio, wardrobe department, editing and recording facilities and even its very own projection room. Instead of demolishing the set after the production wrapped, the construction was kept. Popeye Village remains a major tourist attraction. ⤙*Charlie Cauchi*

Photo © Jonathan Azzopardi (viewingmalta.com)

Directed by Robert Altman
Scene description: Popeye arrives in the town of Sweethaven
Timecode for scene: 0:02:25 – 0:10:55

VICKY AND THE TREASURE OF THE GODS/
WICKIE AUF GROSSER FAHRT (2011)

LOCATION *Għajn Tuffieħa Bay, Għajn Tuffieħa*

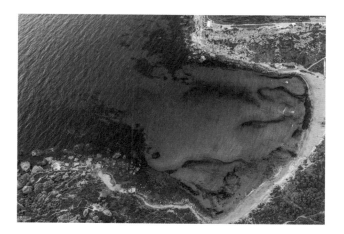

BASED ON *VICKE VIKING*, a series of children's books by Swedish author
Runer Jonsson, the tales of Vicke (*Vicky* in English, *Wickie* in German),
became a popular Japanese cartoon in the 1970s. The popularity of this
young Viking, whose wit saves his fellow villagers from a number of sticky
situations, continued to grow among younger audiences thanks to the
production of two films in 2009 and 2011. Both *Wickie und die starken Männer/
Vicky the Viking* (2009) and *Wickie auf Großer Fahrt* were partially filmed in
Malta. The sandy beach of Għajn Tuffieħa Bay – with its clayey slopes in
the background and flanked by an imposing plateau, known in Maltese as
Il-Qarraba – has appeared in many films. In this case, the bay is home to the
Valkyries, a group of female Amazon-like warriors. Visual effects made the
bay to look like the seat of an ancient civilization, with added ancient stone
sculptures and pyramids in the backdrop of the already picturesque setting.
When the Valkyries capture Vicky's band of Vikings, they are initially
unimpressed and intent on throwing them down a cliff. Only when Vicky
explains that the Terrible Sven is in possession of an amulet, with which he
can find the titular treasure of the gods, do the Valkyries free them, for fear
that Thor's Hammer falls into Sven's hands. **➤Jean Pierre Borg**

Photo © viewingmalta.com

Directed by Christian Ditter

Scene description: *While searching for Snorre, Vicky's band encounter the Valkyries*

Timecode for scene: *0:33:15 – 0:37:02*

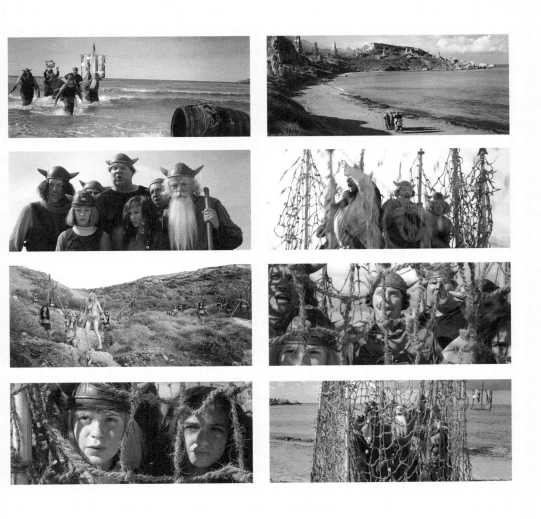

KON-TIKI (2012)

LOCATION *Palazzo Parisio, Naxxar*

THOR HEYERDAHL'S EXPERIMENTAL VOYAGE from Peru to Polynesia in 1947 is a fine example of perseverance. Heyerdahl's expedition was pure fantasy for an industry-driven post-World War II society. Few believed that it could be possible to reach Polynesia from South America without the use of available technology. The film, directed by Joachim Rønning and Espen Sandberg, partially shot in Malta in 2012, describes Heyerdahl's adventure into the unknown. Just like a modern-day Columbus (about whom a feature film and TV miniseries were also shot in Malta), Heyerdahl finds it hard to find financial help. In a last-ditch effort to get funding, he seeks to gain support from the Peruvian president. In a quasi-comical sequence, Heyerdahl (Pål Sverre Hagen) waits to meet the president. The Presidential Palace is in fact the eighteenth century Palazzo Parisio – home to Napoleon Bonaparte during his seven-day stint in Malta on his way to conquer Egypt. Heyerdahl is led from one elaborately adorned room to another, doubly mistaking two medal-clad officers in uniform for the Head of State. In the gardens of the same baroque palace, Heyerdahl is approached by a short gentlemen in civilian clothing. Heyerdahl orders a glass of water, only to discover that this was finally President José Bustamante (Manuel Cauchi) himself. This blunder is quickly forgotten by the president when Heyerdahl proposes that he wants to prove it was Peruvians who first discovered and conquered Polynesia.
❧ Jean Pierre Borg

Photo © Stefan Starface

Scene description: Thor Heyerdahl seeks support from Peruvian president José Bustamante
Timecode for scene: 0:28:28 – 0:29:32

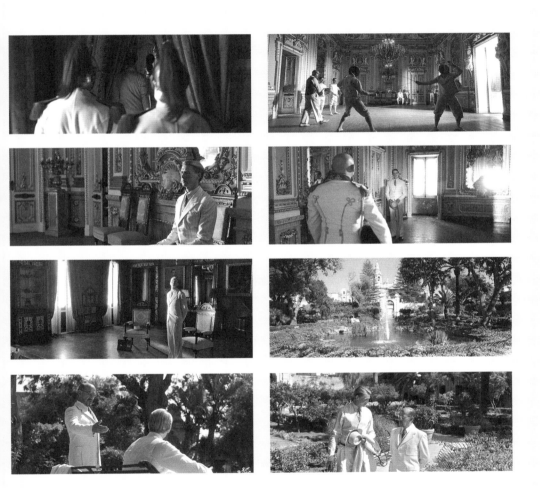

THE DAWN OF THE MEDITERRANEAN'S MINI HOLLYWOOD

Text by
JEAN
PIERRE
BORG

SPOTLIGHT

IN 1931, barely a few months after *Tell England* (Anthony Asquith and Geoffrey Barkas, 1931) was filmed on location in Malta, a journalist, reacting to a letter published in the *Times of Malta*, wrote: 'The island of Malta is ambitious to become a future Hollywood of the Mediterranean' (*Straits Times*, 11 February 1931). Indeed, Malta has played host to countless productions since then, ranging from big-budget Hollywood blockbusters to smaller independent films. Malta's wide variety of natural locations, historical settings and even urban spaces often become a hive of film-related activity. Nowadays, Malta attracts foreign film production based on a combination of factors including financial incentives, versatile locations and experienced film crews. However, almost a century ago, the reasons film-makers shot their productions on the island couldn't be further from anything film-related.

The earliest evidence of feature film-making in Malta dates back to 1925. Reports show that the British Admiralty had granted permission for a fiction film to be shot aboard the Mediterranean Fleet (*Daily Malta Chronicle*, 6 March 1925). The Admiralty had a professed distaste for film, which relented only to make documentaries or re-enactment films when the prospective propaganda offered by the medium became evident (MacKenzie, p.11). Harry Bruce Woolfe possibly earned this unique privilege when he agreed to document the Empire Cruise of the Special Service Squadron for the Admiralty when no one else would. The resulting film, *Britain's Birthright* (1924), was a commercial failure, but by producing it Woolfe won the Admiralty's gratitude, thereby granting him permission to film a piece of fiction aboard the fleet (Bell, p.169).

Directed by Woolfe, British Instructional Films's (BIF) *Sons of the Sea* (1926) is so far considered

to be the earliest feature shot in Malta. A letter sent by Woolfe while directing the film in March 1925, mentions the filming of the salvos of eight 15-inch guns fired together on HMS *Malaya*; gun crews in the turrets; wonderful views of a torpedo attack launched from aeroplanes; and cameras mounted both on an aeroplane as well as on an observing ship. Enthusiastically, he points out that this had never been filmed before, and that he was uncertain whether these scenes would be allowed in a film intended for the public (*New York Times*, 15 March 1925). Indeed, every foot of film shot was scrutinized by the Admiralty and a number of scenes likely to give away sensitive information were deleted (*Daily Express*, 27 March 1925). Of the original six reels, only four are known to have survived. The first two show rare glimpses of naval training at the Greenwich Royal Naval College, while the entire final two reels were shot on land and sea in the surroundings of Għajn Tuffieħa. Here, Malta is used to stand in for an unnamed island in the Eastern Mediterranean. Il-Qarraba is clearly visible and most of the action takes place in the area known as Il-Minżel tal-Majjiesa. Based on the film's official synopsis, we can assume that the two missing middle reels contained the naval scenes alluded to by Woolfe, including scenes depicting the Battle of Jutland and possibly others set in one of Malta's military hospitals.[1]

In 1927, BIF returned to film their World War I naval epic *The Battles of Coronel and Falkland Islands*, again with full Admiralty support (*London Times*, 11 May 1927). Directed by Walter Summers, this film was shot at Cricklewood Studios and on location off Malta and the Isles of Scilly.[2] In 2014, a restored version of the film was re-released and included a newly commissioned score composed by Simon Dobson.

Following *The Battles of Coronel and Falkland*

Above © Filmed in Malta

Islands, Walter Summers was to adapt Ernest Raymond's novel *Tell England* into a film. However, war films were no longer considered popular, leading BIF to shelve the project indefinitely. Summers moved on to direct *Bolibar* (1928) (*Film Weekly*, 7 November 1931). While Admiralty support was the initial reason why BIF had set base in Malta, *Bolibar*, BIF's third film on the island, was surely a direct result of their discovery of the unique film locations offered by Malta. Set in Spain in 1812 during Napoleon's Peninsular Campaign, most of *Bolibar*'s exterior shots were filmed in Mdina and Ħaż-Żebbuġ. It is documented that 900 costumes had to be specially made and brought to Malta, where exterior filming occurred with the help of the Devonshire Regiment, the Royal Artillery and 1,000 Maltese extras. An as-yet-unknown Elissa Landi starred as the film's love interest, many later claiming that it was *Bolibar* that propelled her to Hollywood stardom. Contemporary critics argue that *Bolibar* is a much underrated film, its major drawback being that its release coincided with the arrival of sound (Butler, p.186).

Directed by Woolfe, British Instructional Films's (BIF) *Sons of the Sea* (1926) is so far considered to be the earliest feature shot in Malta.

When *The Battles of Coronel and Falkland Islands* was eventually released, it was an exceptional success. Having cost £18,000 to make, it went on to gross £70,000 in the United Kingdom alone, disproving the notion that war films were unfashionable.[3] This unexpected success convinced Woolfe that *Tell England* could be viable after all, and the project was revived in September 1928 (*Brisbane Courier*, 6 September 1928). Barely two weeks later, however, *The Jazz Singer* (Alan Crosland, 1927), the first complete sound film, was released in London.[4] With the huge investment poured into *Tell England*, it was immediately understood that a silent film would no longer be feasible. The film was consequently further delayed until sound-proof facilities were built and all the necessary sound equipment was acquired (Minney, p.59).

In the spring of 1930, the cast and crew moved to Malta to re-create the Gallipoli landings and eventual evacuation. With the exterior scenes completed, Asquith left for Britain 'browned and happy' with no less than 25,000 feet of footage. Satisfied, Asquith commented that compared to the gruelling exterior work, the remaining interior scenes would be a 'picnic' to shoot (*Film Weekly*, 7 November 1931).

When *Tell England* was finally released in March 1931, it was well received by critics, particularly for its innovative use of sound.[5] Some critics claimed that it was one of the two outstanding British talkies made so far (Minney, p.59). *Tell England* was therefore to be the fourth and last film shot in Malta by BIF.

It was in this context that the *Times of Malta* reader – using the aptly chosen pen name 'Tell Malta' – had written to the paper presenting their views on the benefits that Malta could reap should it become a centre for film-making. The writer went so far as to suggest that Malta could become a future Hollywood or Elstree (*Times of Malta*, 25 December 1930). As years passed, Malta truly became a popular filming location, and when in 1999 Malta was the base for two big-budget films – *Gladiator* (Ridley Scott, 2000) and *U-571* (Jonathan Mostow, 2000) – a CNN journalist referred to Malta as being '[a] Hollywood in the Mediterranean'. Barely three years later, the *London Times* called Malta the 'Mediterranean's mini-Hollywood' (19 April 2002). ✚

NOTES

1. Official *Sons of the Sea* distributor's pamphlet.
2. Rachael Low, *The History of the British Film, 1918–1929* (London, 1971), p.181.
3. Ibid.
4. Rachael Low, *The History of the British Film, 1918–1929* (London, 1971), p.191.
5. Philip Dutton, The Gallipolian (no. 97, 2001–02), p.20–28.

maps are only to be taken as approximates

MALTA LOCATIONS
GOZO AND COMINO

НЕНА

SINGLE-HANDED (1953)

Fungus Rock, Dwejra, Gozo

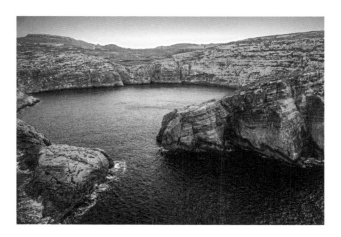

LEADING SIGNALMAN ANDREW BROWN (Jeffrey Hunter) is taken prisoner aboard the *Essen*, a German raider in the Pacific, after the British ship on which he serves is sunk. As the *Essen* is damaged in the exchange, her captain plans to pull into an isolated Pacific anchorage in an attempt to repair his vessel. The dramatic cliffs of Dwejra Bay serve as the backdrop for the ensuing drama as Brown escapes, steals a rifle and a small amount of ammunition, and making his way ashore, climbs up to a spot where he overlooks the anchored *Essen*. Sheltered by the cliffs, he is able to shoot at repair parties, holding up the vital patching of the bow. The delay is sufficient for Allied ships to arrive in time to sink the *Essen* as she finally emerges from the lagoon. The minelayer HMS *Manxman*, with a very realistic gaping torpedo hole painted on her bow, stands in for the German raider *Essen*. This complex scene, which depicts the vessel entering the secluded inlet, was shot by no less than six cameras. Moreover, the production team had to wait five days for the wind and currents to be ideal and could only commence shooting when Lord Mountbatten, commander-in-chief of the Mediterranean Fleet, gave the go-ahead. Once Lord Mountbatten approved that the conditions were right, it was left to the ship's captain, Trevor Lean, to manoeuvre the *Manxman* into the narrow opening between Fungus Rock and Il-Ponta tal-Harrux. 'Don't sink our ship,' the British warned, 'it would cost you $6,000,000, and you'd have no film.' **➻Jean Pierre Borg**

Photo © viewingmalta.com

Directed by Roy Boulting
Scene description: Andrew goes in search of a vantage point
Timecode for scene: 0:48:07 – 0:49:50

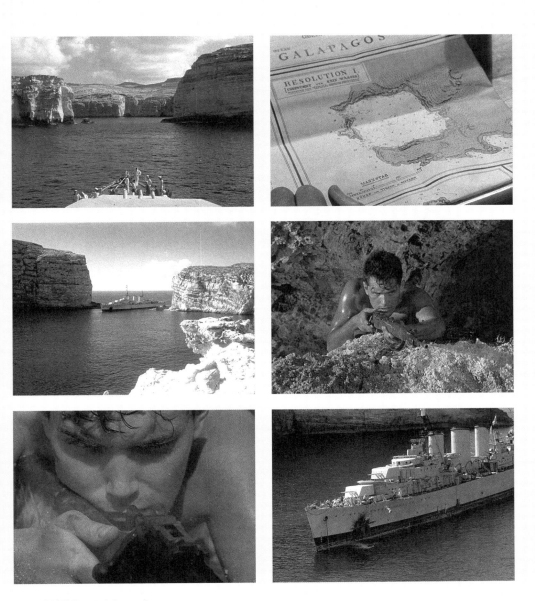

CAN HIERONYMUS MERKIN EVER FORGET MERCY HUMPPE AND FIND TRUE HAPPINESS? (1969)

LOCATION *Ramla l-Hamra, Xagħra, Gozo*

THE MARCH 1969 EDITION of *Playboy* hailed *Can Heironymus Merkin Ever Forget Mercy Humppe and Find True Happiness?* as 'the wackiest, sexiest film yet'. Throughout the ten-page spread, Playmate Connie Kreski's (Humppe) exposed flesh glistens against the jagged Maltese landscape; though ironically this promotional material would have been lost on Malta, where the magazine only became available in 2001. As for the film, actor-writer-director-singer-songwriter Anthony Newley (Merkin) takes navel-gazing to new heights, merging Vaudeville, Broadway, the Music Hall and Fellini into a surreal, erotic autobiographical fantasy. In addition to the titular names, characters like Good Time Eddie Filth (Milton Berle), Filigree Fondle (Judy Cornwell) and Polyester Poontang (Joan Collins) populate the narrative. The latter incidentally is played by Newly's then wife Joan Collins and their children also star in the film. The narrative structure is punctuated by several musical interludes, including a cockney-inspired number 'Piccadilly Lilly', sung to a young Merkin by his uncle J. Poindexter Limelight (Bruce Forsyth). Though now relegated to the realms of cult cinema, it is striking that a film with such a rampant display of nudity was allowed to be made on the beaches of Malta at all. In fact, while the film-makers reported receiving 'tremendous help from local authorities' during pre-production, articles appearing in international press elucidating the erotic nature of the story prompted a backlash from Maltese ecclesiastical and government authorities, claiming that the film would 'besmirch' the image of 'Catholic Malta'. In response, Universal Pictures claimed the film would be nothing 'but a film with artistic value of modern conception'. **⇢Charlie Cauchi**

Photo © Jean Pierre Borg

Directed by Anthony Newley
Scene description: Hieronymus Merkin recalls his uncle Limelight's showbiz advice
Timecode for scene: 0:06:03 – 0:10:05

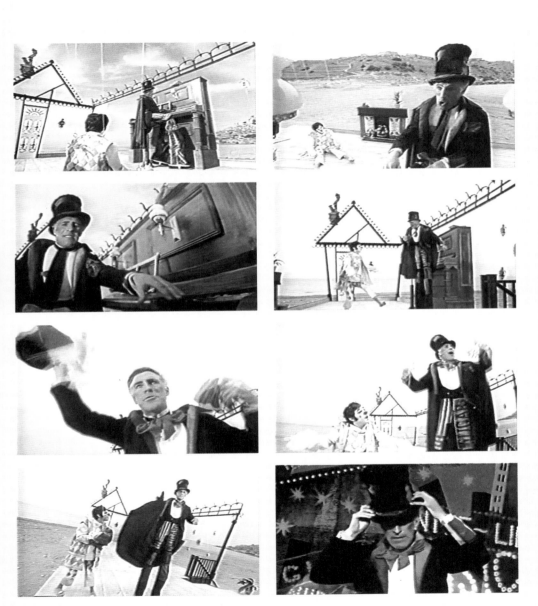

WARLORDS OF ATLANTIS (1978)

Wied il-Għasri, Gozo

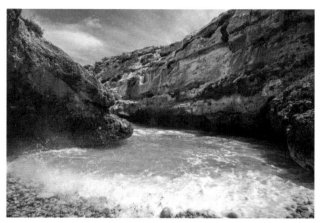

WARLORDS OF ATLANTIS marks the fourth and final collaboration between producer John Dark, director Kevin Connor and actor Doug McClure. While the first three fantasy adventures *The Land that Time Forgot* (Kevin Connor, 1975), *At the Earth's Core* (Kevin Connor, 1976) and *The People that Time Forgot* (Kevin Connor, 1977) were based on works by Edgar Rice Burroughs's 1918 trilogy, *Warlords of Atlantis* was penned by Brian Hayles, a veteran writer for British television. In the film, British archaeologist Professor Aitken (Donald Boisset) and his son Charles (Peter Gilmore) have chartered a ship called the *Texas Rose* to take them out to sea on an expedition to discover the lost continent of Atlantis. Their ingenious plan to explore the depths in a diving bell designed by engineer Greg Collinson (Doug McClure) is initially successful, as they manage to recover a gigantic gold statue. The adventurers are however betrayed by the mutinous crew of their expedition's ship, who want the priceless discovery for themselves. When a giant octopus attacks the boat, heroes and traitors are all dragged to the bottom of the sea where they find themselves within a vast, air-filled cavern beneath the ocean floor. While a mixture of front projection techniques, matte drawings and model work was utilized to recreate the underground cavernous world of Atlantis, the fjord-like tiny beach wedged between high cliffs at Wied il-Għasri provided the perfect ambience for the scene in which the castaways are greeted by Atmir, one of the Atlantean ruling class, and the spear-wielding Guardians, who promise to take them 'to safety'. ➼*Jean Pierre Borg*

Photos © Stefan Starface

Directed by Kevin Connor
Scene description: *Washed ashore in Atlantis, the castaways are greeted by Atmir*
Timecode for scene: *0:25:35 – 0:29:59*

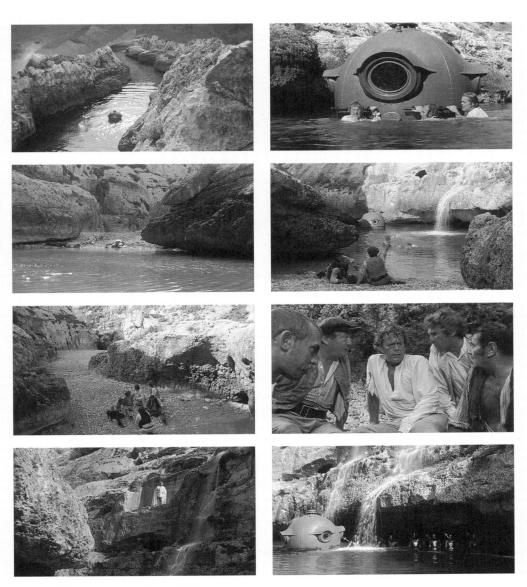

CLASH OF THE TITANS (1981)

LOCATION *Azure Window, Dwejra, Gozo*

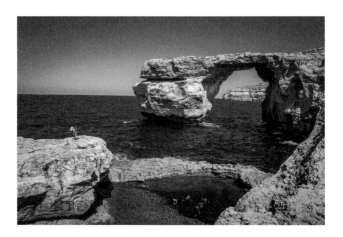

BEFORE *GAME OF THRONES* (HBO, 2011–) got there in 2010, the Azure Window's first foray into fantasy was via *Clash of the Titans*. Inspired by Greek mythology, the film featured a stellar cast, including Maggie Smith as Thetis and Lawrence Olivier as Zeus. However, we cannot talk about *Clash of the Titans* without referencing the artistry of Ray Harryhausen. Using a technique known as dynamation, Harryhausen was able to combine stop-motion animation with live action and real locations. Watching the film now, younger audiences may dismiss the special effects in *Clash* as primitive, but there is definitely a magical, haptic quality to this labour-intensive technique. For this sequence to be effective, Harryhausen and his team built three separate models of the Kraken: a full-length version, approximately three-feet long; a life-size version from the waist up, which was used for close-ups; and a fifteen-foot model, entirely made of sponge rubber, which was used for filming underwater scenes. Located in western Gozo, the Azure Window is a spectacular natural landmark. The arch is 30 metres high and has changed somewhat since filming took place, with an estimated 90 per cent erosion of the outer layer since the 1980s. ➺ ***Charlie Cauchi***

Directed by Desmond Davis
Scene description: Perseus takes on the Kraken
Timecode for scene: 1:44:55 – 1:53:03

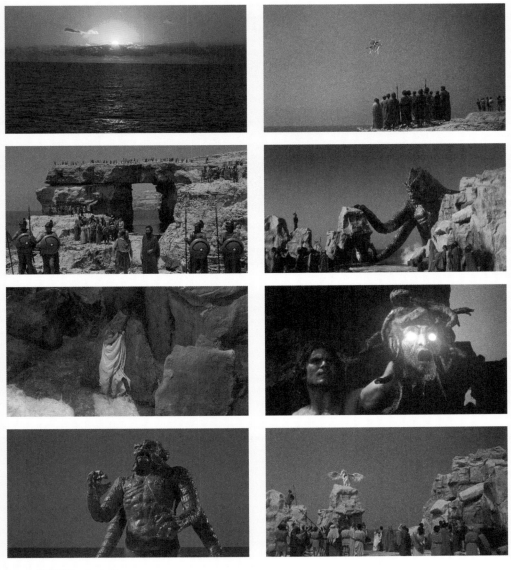

Images © 1981 Titan Productions

AMONG WOLVES/
LES LOUPS ENTRE EUX (1985)

Inland Sea, Dwejra, Gozo

WITH AN ENSEMBLE CAST featuring Jean-Hugues Anglade, Niels Arestrup, Claude Brasseur, Gérard Darmon and Bernard-Pierre Donnadieu, *Les Loups entre eux* is José Giovanni's cinematic adaptation of his eponymous novel. A narrative that explores the limits of honour, loyalty and camaraderie, the film's title and subject matter also play on the French saying 'les loups ne se mangent pas entre eux' ('wolves do not prey upon each other'). When a radical militant group known as 'April 16th' kidnaps the commander-in-chief of NATO's Allied Forces South, a covert rescue team is assembled to free the General. This motley crew is comprised of individuals who were each personally chosen for their abilities and talents to take part in this daring operation, including, among others, a professional mountain climber, an escaped convict and a former army captain. Arriving by boat through an archway naturally hewn from limestone that gives way to Gozo's famed Inland Sea – popular for snorkelling and scuba diving – the rescue task force reaches the compound where they will live and train together for their mission. Their campsite, formerly the training grounds of the British marines, is less than 200 km from where the General is being held in a fortress high in the cliffs above the Mediterranean. As the men dock their boats and disembark, they enjoy a moment of bantering and jokes before settling into their lodgings. The Inland Sea's peaceful shore and clear waters belie the violence of the forthcoming rescue operation and its brutal aftermath. ⦿*Marcelline Block*

Photos © viewingmalta.com / Stefan Starface

Directed by José Giovanni
Scene description: The rescue team's arrival at the training camp
Timecode for scene: 0:38:45 – 0:39:50

Images © 1985 TFI, William Oury, COFCI

BLUE HELMET/CASQUE BLEU (1994)

LOCATION *Comino Hotel, Santa Marija Bay, Comino*

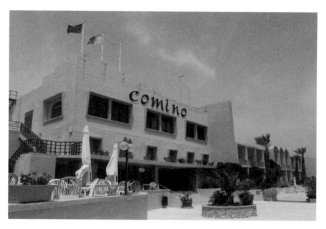

THE PEACEFUL, NEARLY UNINHABITED Maltese island of Comino, well known for its Blue Lagoon, is often called a paradise. Yet in Gérard Jugnot's *Casque Bleu*, Comino – standing in for an island in the Balkans – is anything but. Rather, this paradisiacal vacation spot – recalling Jugnot's appearance in and co-writing of *Les Bronzés/French Fried Vacation* (Patrice Leconte, 1978), in which the Splendid troupe makes fun of Club Med – becomes a prison for a group of tourists who are trapped when civil war breaks out. In an interview, Jugnot refers to *Casque Bleu* as 'Les Bronzés en Bosnie'. Unable to flee the island, the tourists are stranded in its inaptly named 'Peace Inn Hotel' resort – in reality, Comino Hotel's bungalows perched over Santa Maria Bay – now taken over by soldiers. Emerging from their traumatic confinement in a sub-zero temperature room in which they nearly froze to death, the tourists are confronted by a horrifying sight: the resort has been destroyed, its pristine beaches strewn with debris, broken furniture, burning cars, shattered glass and dead bodies – one even floating in the pool. The raw natural beauty and tranquillity of Comino, which is the smallest of the three Maltese islands, contrasts with the damages wreaked by the brutal armed conflict. Paradise, indeed, is lost. ➙*Marcelline Block*

Directed by Gérard Jugnot
Scene description: *A group of tourists are confronted by a horrific sight*
Timecode for scene: *1:08:09 – 1:11:05*

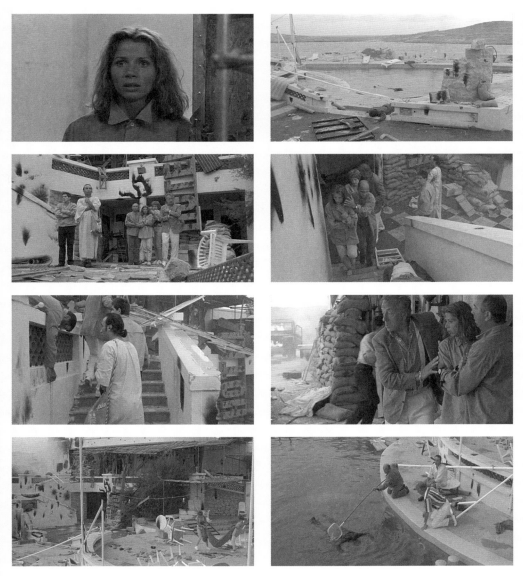

TROY (2004)

LOCATION *Blue Lagoon, Comino*

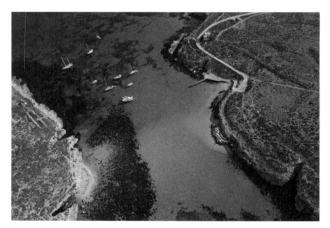

SHOT IN THE BLUE LAGOON, the channel between the islands of Comino and Cominotto, the scene captures the moment when Achilles (Brad Pitt) visits his mother Thetis (Julie Christie) before deciding whether to join the attack on the city of Troy. Preceded by shots of a galley with Comino in the background, the discussion between mother and son takes place in the crystal clear waters of an inlet facing the Blue Lagoon. An official still of this scene showed a typical Maltese rowing boat (*dgħajsa tal-pass*) accompanying the galley, a detail which did not make it into the final cut of the film. While the palace in the background has been digitally created, the sea's varying shades of blue has not. The play with the colour blue is also used in the characters' costumes, both of which are blue, including Thetis' jewellery, in reference to the fact that she was a Greek sea-goddess. Thetis presents Achilles with the possibility of either living a peaceful life and eventually being forgotten, or dying a heroic death where he will be remembered for 'thousands of years'. The viewer identifies with Thetis, who as a goddess, knows what the future holds. While in Homer's *Iliad*, Achilles' death is not described, the film follows the ancient Greek legend, in which Achilles dies after Paris' (Orlando Bloom) arrow strikes his only vulnerable spot – his heel. Ironically, during filming, Brad Pitt also tore his Achilles tendon halting the production for almost three months. ↝*Jean Pierre Borg*

Photos © © Clive Vella (viewingmalta.com) / viewingmalta.com

Directed by Wolfgang Peterson
Scene description: Achilles meets his mother Thetis
Timecode for scene: 0:33:24 – 0:35:57

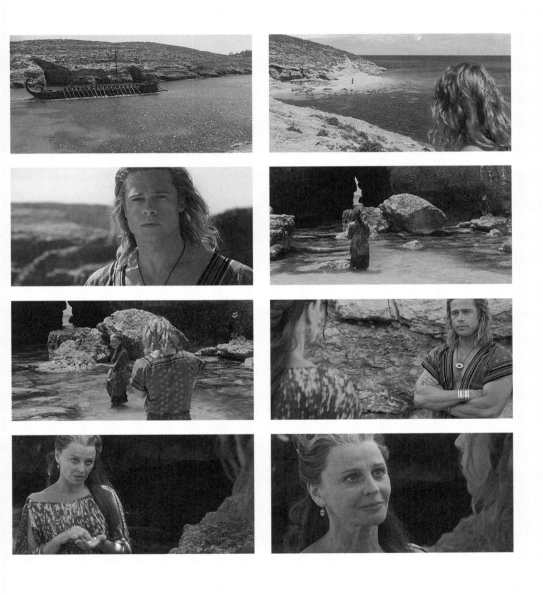

FORT ROSS: IN SEARCH OF ADVENTURE/
ФОРТ РОСС: В ПОИСКАХ ПРИКЛЮЧЕНИЙ (2014)

LOCATION *Xwejni, Gozo*

PRESENT IN VARIOUS seaside locations around Malta and Gozo, salt pans are shallow hollows carved into the soft bedrock to harvest salt through naturally evaporated sea water. The long stretch of coastline at Xwejni, with salt pans dating back to the seventeenth century, is still used for harvesting sea salt using this traditional method. Very popular for rod-fishing, scuba diving and hiking, Xwejni provided the perfect setting for the construction of a pirate village, used for the Russian film *Fort Ross*. Departing from a factual incident when a Russian colony was set up in California in 1812, the plot involves pirates, time travel, love, American Indians and plenty of comedy and adventure. While recording a reportage on the occasion of the 200th anniversary of the setting-up of Fort Ross in California, Dmitriy (Maksim Matveyev) and his television crew find themselves transported back in time to the nineteenth century by way of a time-travel app on Dmitriy's smartphone. Within minutes, boom operator Margo (Anna Starshenbaum) gets kidnapped by a band of pirates. It's up to Dmitriy and his cameraman, Fimka (Maksim Vinogradov) to come up with a daring plan to rescue Margo from the pirate ship, moored just a short distance away from the pirate settlement. Inspired by action/adventure/comedy franchises such as *Indiana Jones* and *Allan Quatermain*, havoc reigns when the pirates bombard the pirate settlement with cannon fire, blowing up anything between them and the escapees, to smithereens. ◆ *Jean Pierre Borg*

Photo © viewingmalta.com

Directed by Yuriy Moroz
Scene description: Margo is rescued from the Pirates
Timecode for scene: 0:50:44 – 0:53:00

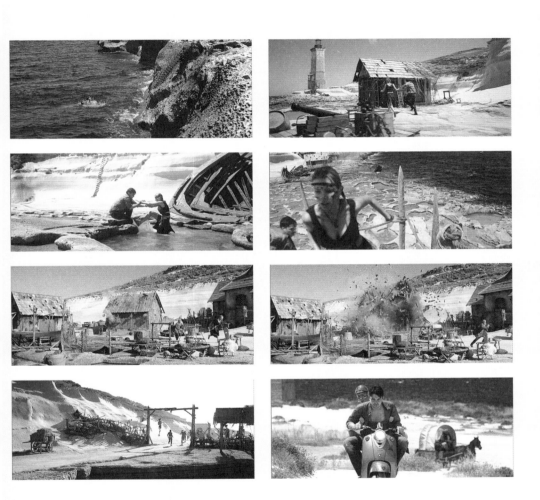

GO FURTHER

Recommended reading and useful websites

BOOKS

The History of the British Film: 1918–1929
by Rachael Low
(Routledge, 1971)

Canon Fire: The Art of Making Award-winning Amateur Movies
by Cecil Satariano
(Bachman & Turner, 1973)

The Films of Anthony Asquith
by R. J. Minney
(Cranbury, 1976)

Malta and Gibraltar Illustrated: Historical and Descriptive, Commercial and Industrial, Facts, Figures and Resources
by Allister Macmillan
(Midsea Books Ltd, 1985 [1915])

Silent Magic:
Rediscovering the Silent Film Era
by Ivan Butler
(Columbus Books Ltd, 1987)

The Contemplation of the World:
Figures of Community Style
by Michel Maffesoli
(University of Minnesota Press, 1996)

Peinture, photographie, film: Et autres écrits sur la photographie
by László Moholy-Nagy
(Editions Jacqueline Chambon, 1993)

The Royal Navy, Seapower and Strategy between the Wars
by Christopher M. Bell
(Stanford University Press, 2000)

British War Films, 1939–1945:
The Cinema and the Services
by S. P. MacKenzie
(Hambledon Continuum, 2001)

Architecture From the Outside:
Essays on Virtual and Real Space
by Elizabeth Grosz
(MIT Press, 2001)

The Manoel Theatre: A Short History
by Paul Xuereb
(Midsea, 2012)

V.
by Thomas Pynchon
(Bantam Books, 1981 [1963])

The Founding Myths of Architecture
by Konrad Buhagiar et al
(Artifice Books on Architecture, 2015)

ARTICLES

'Interpreting the Landscape of the Maltese Islands'
by Conrad Thake
In *Traditional Dwellings and Settlements Review* (1994)

'The Earliest Film-makers in Malta',
by Giovanni Bonello
In *Treasures of Malta Vol. 17. No. 1* (2010)

'Cinemas in Malta Before World War I'
by Giovanni Bonello
In *Treasures of Malta Vol. 17. No. 2* (2011)

ONLINE

Malta Movie Map
www.maltamoviemap.com

Malta Film Commission
www.maltafilmcommission.com

Malta Film Tours
www.maltafilmtours.com

Visit Malta
Malta Movie Locations Podcasts
www.visitmalta.com/en/podcast-movie-locations

Valletta Film Festival
www.vallettafilmfestival.com

JEAN PIERRE BORG is founder and chairperson of Filmed in Malta, a Malta-based NGO dedicated to researching, documenting and raising awareness about the long history of film-making on the island. Jean Pierre, has given a number of lectures and published articles on local printed media regarding films shot in Malta. His research has led him to rediscover that the first film shot in Malta was *Sons of the Sea* in 1926, followed by the 1927 *Battles of Colonel and Falkland Islands*.

CHARLIE CAUCHI is currently a doctoral candidate in the Department of Film Studies at Queen Mary University of London. Using Malta as a case study, her current research aims to provide an in-depth analysis of the ways in which Malta operates as a place for film production for foreign and local projects. Publications include '"A Significant Cultural Industry": Mapping Audio-visual Education on the Island of Malta', in Mette Hjort (ed.), *The Education of the Filmmaker in Europe, Australia and Asia* (Palgrave Macmillan, 2013) and 'Cinema in Malta or Maltese Cinema? Politics and Identity on Screen from Independence to EU Accession', in Janelle Blankenship and Tobias Nag (eds), *European Visions: Small Cinemas in Transition* (Columbia University Press, 2015).

CONTRIBUTORS

GIOVANNI BONELLO was judge at the European Court of Human Rights for twelve years. Before that he was a lawyer, specializing in human rights litigation, defending 170 human rights lawsuits before local and international courts. He is the author of 23 books on art and history, four of which won the national Best Book of the Year Award. Three full-feature books and a special edition of a law journal have been published about his legal and cultural achievements. He was President of the Malta Historical Society, and is general editor of Fondazzjoni Patrimonju Malti publications, Superintendent of the Palace Regeneration Project and Chairman of the University Ethics and Disciplinary Board. He was a member of the main board of the Malta Environment and Planning Authority and chaired the National Committee for the Reform of the Administration of Justice.

MARCELLINE BLOCK edited *World Film Locations: Paris* (Intellect, 2011; Korean translation, 2014); *World Film Locations: Las Vegas* (Intellect, 2012); *World Film Locations: Prague* (Intellect, 2013); *World Film Locations: Marseilles* (Intellect, 2013), which she co-translated into French as *Filmer Marseille* (Presses universitaires de Provence, 2013, and *World Film Locations: Boston* (Intellect, 2014), in addition to *Situating the Feminist Gaze and Spectatorship in Postwar Cinema* (Cambridge Scholars Publishing, 2008; 2nd edn, 2010; Italian translation, 2012). She co-edited *The Directory of World Cinema: Belgium* (Intellect, 2014), *Gender Scripts in Medicine and Narrative* (Cambridge Scholars Publishing, 2010; Italian translation, 2014); and *Unequal before Death* (Cambridge Scholars Publishing, 2012). Her articles and book chapters about film, literature and visual art have appeared in English, Chinese, French, Italian, Korean and Russian. She lectured about 'Paris Onscreen' at 92Y TriBeCa and 'Prague in Film' at the Bohemian National Hall (New York Czech Center).

REBECCA CREMONA graduated with a first class BFA in Film and Comparative Literature from the University of Warwick, UK. That same year, her first short *My Story/L-Istorja Tiegħi* got her into the American Film Institute Conservatory. There she directed three short films and was production designer for three others. In turn, these shorts garnered a generous scholarship

from Art Center College of Design, where Rebecca transferred to complete her Master's Degree in Directing. At ACCD she made *Magdalene* which won a DGA student Jury Prize, an Honourable mention at the student EMMYs, and was picked up for distribution by Shorts International. Multiple Oscar winner Janusz Kaminski stated that "*Magdalene* is unparalleled in beauty and sensibility". During her studies Rebecca worked on various films like Spielberg's *Munich* and Amenábar's *Agora*. Through her company, Kukumajsa Productions, she has made her first feature film *Simshar* (2014) which was Malta's first ever Oscar submission for the Best Foreign Language category.

GUILLAUME DREYFUSS joined Architecture Project in 2001 and is an expert in the identification, assessment and presentation of values associated with heritage assets, as well as in the preparation of restoration, maintenance, and management strategies. Guillaume obtained a Master's degree in Built Environment, Sustainable Heritage from University College London. He is also co-editor of *The Founding Myths of Architecture* and *A Printed Thing*. Before joining AP, Guillaume gained experience in France in museum curatorship and exhibition management.

MONIKA MASLOWSKA is a screenwriter and a scholar who works across experimental and classic screenwriting practice. She lectures in screenwriting and cinema at the Faculty of Media and Knowledge Sciences at the University of Malta. She is currently pursuing her Ph.D. degree with the School of English at Bangor University.

KENNETH SCICLUNA studied film at the University of Malta, under Professor Saviour Catania. He is an award-winning film-maker, a Berlinale Talent, and a member of the European Film Academy. In 2001 he completed a feature-length student film, *Genesis*, which was the first Maltese film in decades to screen in foreign festivals. Kenneth's subsequent works have since participated in more than sixty festivals around the world; *The Isle*, a short commissioned by Zentropa, was called a "most pleasingly cheeky surprise" by *TimeOut London*, and *Daqqet ix-Xita* (2010), the first Malta Film Fund short, won awards for its direction and cinematography. The sea has featured in all of his films, and often functions as a means of attempted, if often frustrated, escape. See www.seawardfilms.com.

JAKE MAYLE is an experienced film-maker who has worked all over the world in a variety of production roles. He has worked in Malta directing the second unit for the UK Television Production*What We Did on our Holiday* starring Shane Ritchie, Roger Lloyd-Pack and Pauline Collins in 2006.

MARC ZIMMERMANN is a Senior Consulting Conservation Engineer, cinema historian and NGO President with a passion for cinema and heritage. As the Founding Chairman of the Cinema Heritage Group he has been documenting and preserving cinema-going history in several countries worldwide. In his role of President of the Malta Film Network, he has been leading efforts to promote cinema-going culture, and to foster European film and heritage preservation. He is the author of *The History of Dublin Cinemas* as well as academic textbooks and numerous articles on the subjects of cinema, heritage and preservation. Marc is dedicated to keeping the history of cinema and movie-going alive, and to ensuring a bright future for silver screens. See www.CinemaHeritageGroup.org.

FILMOGRAPHY

All films mentioned or featured in this book